DRAWING
OUTDOORS

W9-BOZ-386

Henry C. Pitz DRAWING OUTDOORS

Watson-Guptill Publications • New York
Pitman Publishing • London

To Molly

Paperback Edition
First Printing, 1977
Second Printing, 1978
Copyright © 1965 by Watson-Guptill Publications

First published in the United States by Watson-Guptill Publications,
a division of Billboard Publications, Inc.,
1515 Broadway, New York, N.Y. 10036

Published in Great Britain by Pitman Publishing Ltd.,
39 Parker St., London WC2B 5PB
ISBN 0-273-01155-3

Library of Congress Catalog Card Number: 65-15949
ISBN 0-8230-1417-7 pbk.

All rights reserved. No part of this publication may be
reproduced or used in any form or by any means—graphic,
electronic, or mechanical, including photocopying, recording,
taping, or information storage and retrieval systems—without
written permission of the publisher.

Manufactured in U.S.A.

Contents

I. The Outdoor Sketching World

The material for sketching outdoors is just outside the door. It can be a thousand miles away but need be only a few steps. The sketcher has the whole world for his studio, a breathtaking thought, but he is often unaware of that portion of material which is just at hand, under his eye. The day-by-day familiarity of his own street or road can develop a kind of blindness.

Learning to See

The rewards of sketching are many; among the most important are not only training the hand but educating the eye. And sharpening the eye can not only train it to deal swiftly and accurately with the forms immediately before it, but can make the eye discover interest and opportunity in forms it has taken for granted. The artist's eye is one that can roam, investigate, and be surprised. It is the organ of his sense of wonder, and wonder can be stirred not only by the strange and new, but by rediscovering the accustomed. In fact, the value of the artist's gift centers about the fact that he sees what other people see, but he sees in an *enhanced* way.

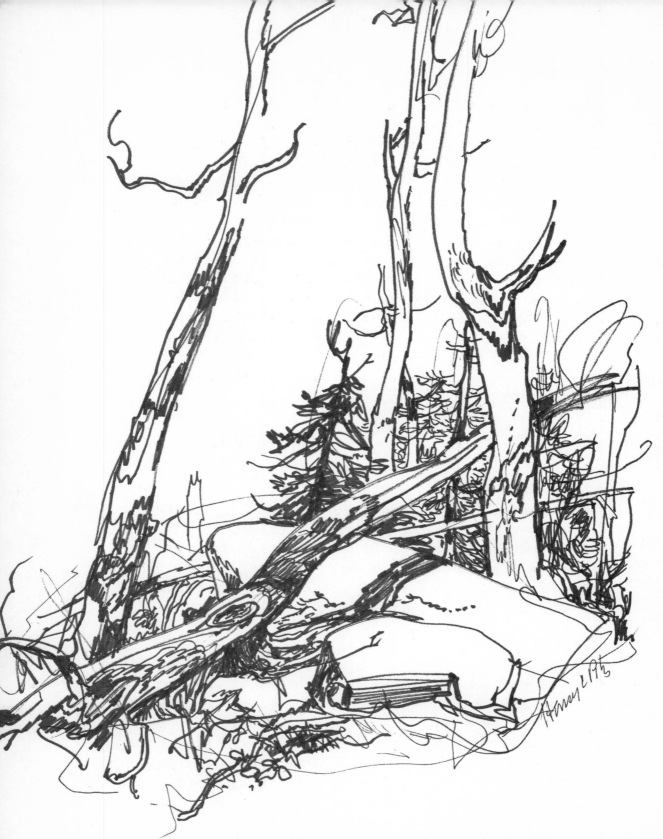

Henry C. Pitz A rapid sketch of a small clearing in Maine, executed with a nylon-tipped pen.

So the artist, no matter where he may live, is surrounded with pictorial opportunities. He may choose to travel far in search of them, but the subjects are also on his doorstep. In fact, one of the artist's problems is the embarrassment of riches which assails him from all sides. He suffers not from lack of material but from lack of time.

The artist often considers time a tyrant and an enemy, but his enemy can be made to work for him if he is shrewd enough. A long day's expedition to a favorite sketching spot may be ideal, but a five or ten minute interval a few steps away can also be fruitful. It would be a rare person who could not find the usual day studded with five or ten minute intervals which could be put to work. If a few simple materials are at hand you can be drawing almost immediately. And the prodding of severely limited time can be beneficial. You can learn to be alert, economical, and efficient. You can learn to pack expression in a few meaningful lines. The best drawings are not always the most labored.

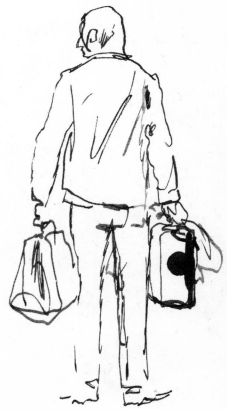

Henry C. Pitz A sketch of a hotel porter, executed on the spot with an ordinary fountain pen.

Naturally, every sketcher has his individual orbit, wide-ranging or limited. If you are a part-time sketcher with a bread and butter occupation to take most of your time and energy, it may be a problem to find scraps of time. And the scraps of time, when they do arrive, may be unpropitious.

There is lunch time. A restaurant or lunch counter can be a gold mine of sketching material but if it is crowded elbow to elbow at the noon-time rush, you may have neither sufficient room nor the courage to brave the stares of the curious. But if you could find a corner seat before or after the rush, a sketchbook in your lap or behind a newspaper might make it possible to capture a few notes.

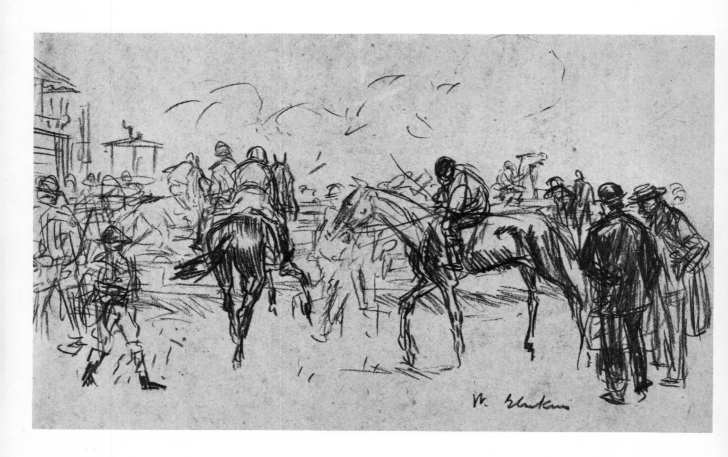

William Glackens Race Track. *Philadelphia Museum of Art Collection.*

There is also the bus or train. Again the pressure of crowds may nullify all efforts, but if you can find times when there are not many passengers, you may jot down a few telling lines behind a book or newspaper.

Using the Window

Windows are usually fine vantage points. Even a window facing an airshaft can offer a study of bricks and window frames and sometimes a leaning figure; but most windows open upon some segment of the active world. There are not only the windows of your room

William A. Smith A pencil drawing made in Mandalay, Burma, across the double pages of a sketchbook.

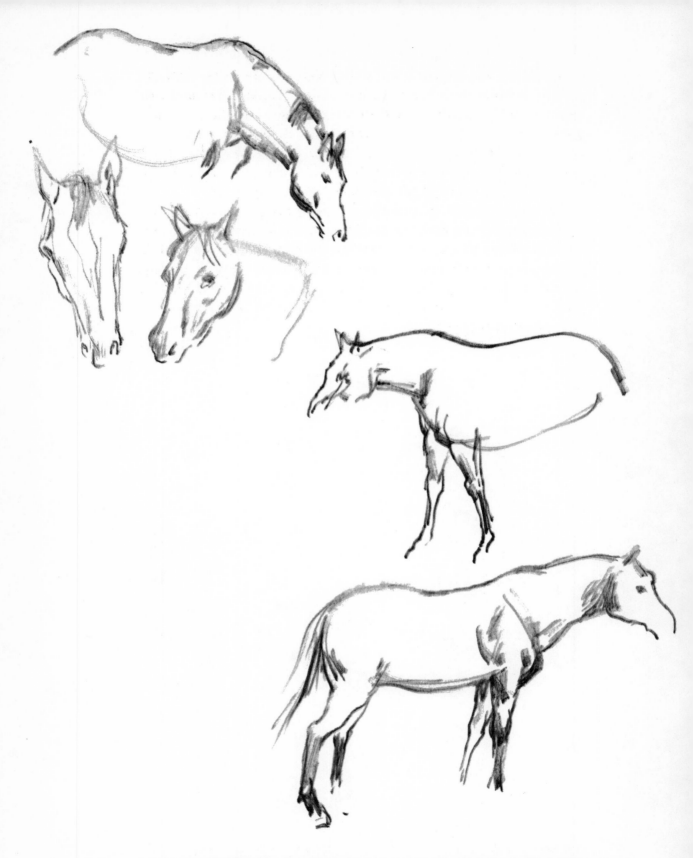

Henry C. Pitz Sketches made from the top of a corral fence with felt tip pen.

or home, but windows of friends and relatives; of offices, or of the elevator lobbies in office buildings; of bus and rail terminals; of airports, public buildings, and stores. Windows can yield remarkable material, and they permit you to sketch without concessions to the weather. Probably the most useful of all vantage points are automobile windows. You can hunt your subjects fairly freely, limited only by unpaved surfaces and *No Parking* signs.

The important thing is that sketching is not necessarily a question of elaborate preparation and large segments of time. Everyone enjoys the long half or whole day sketching expedition and should indulge in it as often as possible. Long expeditions are part of the artist's necessary training, but the quick, opportunistic sketch has its place, too, and together they make for a well-rounded sketching experience.

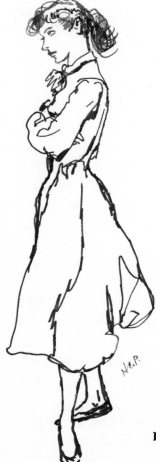

Henry C. Pitz Quick sketch of female figure.

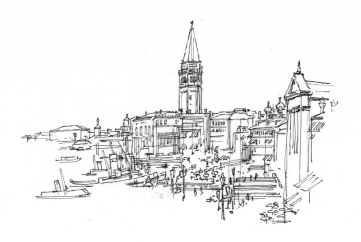

II. Simple Preparation

If you are going to make much of your sketching time, particularly if your time is limited, certain plans and preparations must be made and a flexible system worked out to fit your own particular needs. The first preparations must be made in the mind.

Preparing Yourself

No one questions the value and enjoyment of a long day's sketching in the open, but the practicability of a few minutes' drawing at intervals may raise doubts. Can something be done in five or ten minutes that will make the effort worthwhile? Yes. First, you must adjust to a realistic standard of values. Do not expect the same fulsome drawing in a few minutes that you would expect after a morning or afternoon session. In fact, the whole plan of attack for the quick session differs from the long one.

Learning to Select

The quick sketch is a jotting, a note, a hint, a suggestion. It does not attempt the impossible but drives at the heart of its subject, trying to set down a notation of the prime essentials. It improvises. It takes short cuts. It concentrates on one of the artist's prime prerogatives: the art of selection. Here is one of its great benefits. The quick sketch forces you to concentrate on the important factors and so makes constant and instantaneous demands upon your power of selection. If this constant exercise does not strengthen and improve the faculty of selection, probably nothing will.

The quick sketch makes demands upon your hand too. Here too, constant exercise should develop manual control, should discourage the aimless scribble and the vacillating line. And as in all the arts, constant practice is the basis for achievement.

The quick sketch, then, is not a substitute for the longer study, but its complement: both are necessary to a well-rounded development. But, particularly for those whose lives do not permit of long and numerous study sessions or sketching expeditions, the quick sketch supplies the need for frequent drawing and observation. Time can be telescoped; it is possible to absorb more from ten minutes' concentration than from three hours of languid puttering.

Choosing Your Equipment

If we have a clear idea of the goal of the quick sketch and its limitations, we can prepare to extract the most from its opportunities. We must have materials that are simple and readily available. If possible, the equipment should be easy to carry without inconvenience most of the time. This narrows down the equipment to a pocket-sized sketchbook or pad and a simple drawing tool like a pencil, hard crayon, or perhaps a fountain pen, or felt tip pen. If you select a pencil or crayon, you might add an eraser.

Pencils and Crayons

There is a wide variety of pencils and crayons and personal choice should determine the kind you use. For quick work, the softer grades of lead or crayon are usually preferable. A hard pencil, for instance, is an excellent tool, but rather better suited to careful, precise, and painstaking work. The softer points in the 4, 5, and 6B grades glide over the paper more freely, and are more capable

of rendering thick to thin lines. The inherent quality of the softer leads induces freer handling. Carbon pencils are also excellent. Lithographic and other wax-based crayons have their own special qualities but they seem more suited to larger scale drawings than the pocket-sized pad.

Pens

Fountain pens and felt tip pens are very convenient tools to carry with you. There are several fountain pens made especially to carry drawing (India) ink. They are claimed to be immune to clogging from the carbon contained in India ink, but experience has cast doubt upon this claim. An ordinary fountain pen filled with writing ink is much more likely to stay in condition. I recommend a black or brown writing ink, or a mixture of the two.

There are many types and makes of felt tip pens with a wide variety of nibs. These nibs come pointed, wedge, and T-shaped, and square and triangular in cross-section. You can easily remove these nibs and can trim them with a razor blade to the desired kind of drawing point or edge. Some of these felt pens are of the fountain variety with reservoirs to be filled with a dropper; other felt pens are of the dip variety (less suited for casual sketching); and still others are of the sealed-in-reservoir, or "throw-away," type. These pens use an oil based dye which penetrates greatly, sometimes striking through to an underlying sheet of paper. The permanence of the dyes is questionable. More recently some pens are

Henry C. Pitz Fountain pen sketch with dark accents smudged with a finger tip.

Henry C. Pitz Sketch from a hotel balcony in Lisbon, made with a fountain pen containing writing ink. The tone areas were made by rubbing with a moistened finger.

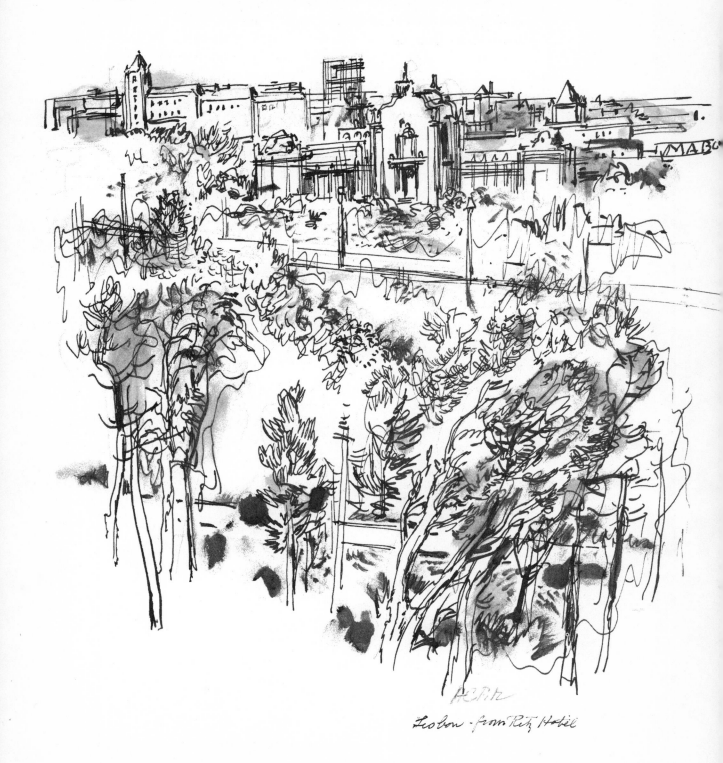

Lisbon - from Ritz Hotel

being made with a water based ink. This seems to have less penetration and better claims to permanence. All of these pens must be capped firmly when not in use or the felt nibs will clog and harden. The nibs using oil based inks will become workable again if you soak them in a special solvent; the water based inks dissolve if you soak them in hot water. Although both types of ink dry almost immediately, they have different characteristics: The oil based dyes are indelible and will not smudge; the water based inks are susceptible to moisture smudging unless you spray the drawing with fixatif. Sometimes this smudging quality is an advantage as when you want to blend and model with a moistened finger tip.

Pads and Paper

Drawing pads and sketchbooks come in many sizes and types. Paper surfaces play an important part in the character of a drawing, and most artists enjoy experimenting with all kinds of paper.

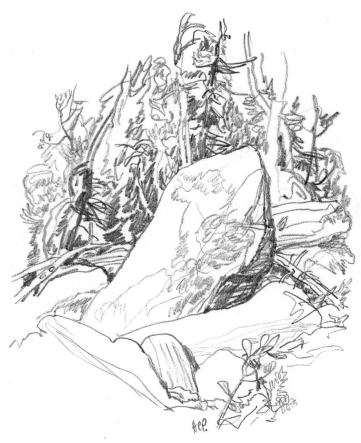

Henry C. Pitz A graphite pencil sketch.

18

For the small pocket-size, however, the fascinating rougher textures are less suitable and a good grade of bond paper is probably the best all-around surface.

Besides the sketchbook or pad, you could use sheets of paper fastened to a backing of stiff cardboard with rubber bands, but there are at least two arguments in favor of the book: pads are more likely to be preserved, and sketches are in sequence. Loose sheets easily become torn or lost, and the artist is likely to throw away those he considers failures. There is much to be said for preserving *everything* at this stage: you can see all the evidence, good and bad. It is better to face the whole record without raising the average artificially by discarding the worst. This is the stage when your weaknesses can be corrected by consciously practicing to strengthen them.

Although I have enumerated the bare essentials for rapid sketching, you may add to them as circumstances or personal preferences dictate. For instance, probably there will be many times when you can carry a larger sketchbook or pad without inconvenience. Varying the size would be helpful, because it is a mistake to become too addicted to drawing on the same scale. Continual drawing on the restricted size of the small pad may encourage a cramped and spiritless style. It is also wise to change the type of your point occasionally to avoid getting into a rut.

Practicing with Your Equipment

With your materials readily at hand, you may alert yourself to all the sketching opportunities that life may offer. When the opportunities do present themselves, the artist will try to translate the scene before him into simple graphic terms. Most subjects are seemingly complex and wear a cloak of confusion. The artist develops a way of seeing that pierces the confusion and selects those elements that are important to him. He states these elements simply and rapidly on his paper. Each sketch becomes an exercise in selection and the sense of selection grows sharper and wiser by practice.

It is this practice that develops the artist. There is no substitute for it. The practice may and should take many forms, from the rapid jotting of a few minutes, to week-long easel pictures. Graphic expression is the artist's function and its health lies in exercise.

III. The Land

The land has its anatomy. It has a rock core; a skeleton that lies deep or protrudes slyly, or boldly and dramatically. Its skin of earth is scant or deep and soft. Its clothing is the multitude of green vegetable life. All these elements fuse and interact in an endless profusion of forms and this profusion is the artist's hunting ground. The land is staggering in its variety and no artist can hope to master all of it. But there is ample room for a lifetime of discovery and each can make his own contribution.

Selecting Your Subject

The beginner is naturally confused when facing his first landscapes. He is starting an art which involves search, time, and practice. He must try to group and simplify the wealth of forms before him. Before putting pencil or brush to paper, it would be helpful for him to survey the area and to imagine himself walking in it, into its farthest reaches. Over what planes would he be trudging: uphill,

downhill, on the level ground? On what surfaces would he be treading: grass, rock, soft loam, powdery dust? Would he be walking in sunlight or shadow? The answers to all these questions are important, for this is the stuff of his projected picture. If he doesn't know these answers, his pencil will not find them for him. If his sketch area is shallow, he may actually walk into and through it, an activity which would not be wasted time. He would probably learn things that could be used in all future sketches. It is simple psychology that acquiring the *feel* of things, entering into their being, prepares the way for more fluent and knowing drawing.

One mechanical way of cutting down confusion is to use a *viewer,* two L-shaped strips of cardboard held together by paper clips to form a square or rectangular opening. Held before the eye, the viewer can be adjusted to frame in the desired vista, and to block out the distracting elements that border it.

A simple viewer made of cardboard.

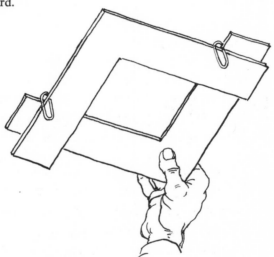

The Focal Point

Once the desired area has been framed, you can concentrate upon what actuated the choice: almost certainly some object, some grouping, some effect; a center of interest, a focal point. This point is the core of the picture and all other elements in the picture will be disciplined to enhance or be subsidiary to the center of interest.

Although there can be no law telling where a picture should be started, it is usual to begin at this core, where the fate of the picture hangs. Moreover, if time or opportunity is very limited, you should make at least some recording of the prime center of interest and ignore the tributary elements if necessary.

Arranging the Forms

With the first stroke of the pencil or brush, consciously or unconsciously, you are beginning an exercise in selection. Selection is *design, composition, arrangement,* call it what you will. Selection means that confronted with the infinite detail of nature, you must discard lavishly, choosing only those things which appeal to you. Select not only the things you wish, but place them *where* you wish. You should feel in command of your picture; free to eliminate, free to mute, free to emphasize. It is with this power of selection that the artist leaves his stamp on his material.

So having chosen a central motif for your picture, you must carry your skeleton further. You cannot hope to depict every aspect of your choice; you must decide what to emphasize, what to mute, what to suppress. You may decide that a mere outline of a hill will suffice for your purpose or, on the other hand, a full tonal development may be necessary. You will naturally give your greatest attention to the form or forms in your center of interest, handling the surrounding or subsidiary forms to keep them in their secondary role. This can be done in many ways: by drawing them in less detail; using less contrast; drawing with a less forceful line, making certain that their forms do not compete with those of the focal point, placing them out of the most important path of the eye.

Drawing in Depth

As soon as you begin placing your forms, appraising the relationship of one to another, you may encounter the problem of perspective. Perspective is usually considered a subject in itself and can become very involved. It should be studied, but in the early experience of outdoor sketching you need only to be aware of a few obvious factors. Objects seem to diminish in size as they recede into the distance. They diminish in a regular progression. For convenience, we assume an imaginary horizontal line in our composition, the *horizon,* which is theoretically on a line with the artist's eyes. You look *down* upon those planes which lie below the horizon, and *up* to those which are above the horizon. If objects of an equal size recede from us, a line drawn through their bases and tops to a single point on the horizon (called the *vanishing point*) will define the heights of such objects. The diagrams on the facing page will explain this principle better than words.

Perspective Objects of the same size appear to diminish in size as they recede from the eye. Those parts *above* the eye level (horizon) dip down towards the horizon and the portions *below* slant up to the same horizon.

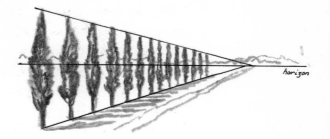

Another factor you may encounter when you draw in depth is the overlapping of objects: nearer objects conceal (or partly conceal) objects behind them. This is a potent element in achieving depth and a sense of solidity. Overlapping objects not only establish a feeling of receding planes, but are also of great importance in the sheer arrangement of a picture. Through control of overlapping, the artist can establish a strong path for the eye to follow.

Still another factor in depth is that the focus softens as objects recede farther from the eye, and that distance produces a graying effect upon tones and colors. Distant forms will take their place if we draw them with definition that is less sharp and with values of less contrast than those you use in defining nearby forms.

The above factors are of everyday familiarity but their expression with brush or point are matters of control and experience. They are factors that should not be employed blindly, but with discrimination and in the light of their effect upon the intent of your picture.

Overlapping Objects When one shape overlaps another, as a fence before a tree, a tree before a house, a house before a bank of trees, the successive shapes interrupted by other shapes create layers of distance.

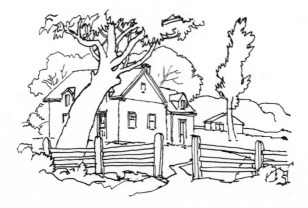

Simplifying the Depth

Any segments of landscape upon which you choose to concentrate may vary greatly in depth, from a few feet to many miles. Subjects of shallow depth will usually present fewer difficulties than those of great penetration, but the need for condensation and simplification is always desirable. The classical division of landscape depth into three major planes (*foreground, middle distance,* and *distance*),

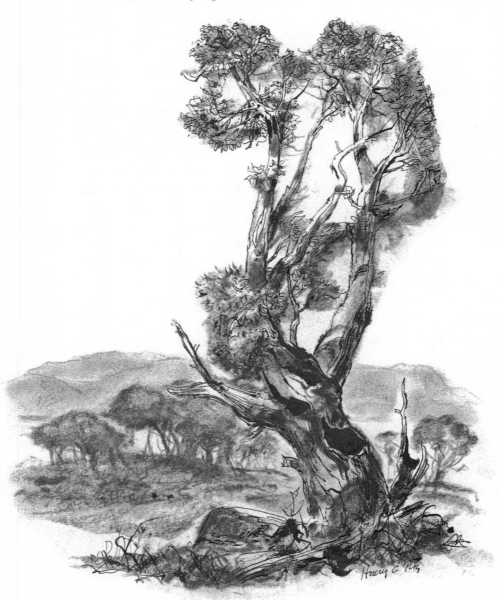

Three Planes The large dark tree with rocks, stumps and weeds at its base is the foreground area; the field with its bank of trees beyond is the middle distance; the line of hills is the distance.

is still a valid and helpful division, applicable to most landscapes. The three divisions almost define themselves. The *foreground* is the plane from which we advance into the picture, the nearest plane, projecting from the picture's lower edge to a depth where detail is readily noticeable. *Distance* is, of course, the area on or near the horizon which may be relatively close or as far away as the eye can see. The *middle distance* is the somewhat indeterminate area between foreground and distance. This terminology is not to be regarded as an invariable rule or a hampering factor. It is useful for simplifying the multiplicity of nature and for imposing a kind of order upon any given scene.

Most landscapes present a series of retreating planes, some of which are concealed or partly concealed from us. When a foreground plane spreads before us, and a succeeding plane dips out of sight, and a third one appears at a distance, we are encountering a constantly recurring factor in landscape. At the point where the first plane ends and the third one appears is a point of natural transition where you should pause and study. It is at this point that you are offered an opportunity to draw the edge of the nearer plane with some care and to indicate the rising plane beyond it with less contrast.

Light and Shadows

The landscape sketcher is certain to be awakened to the power and mystery of light. Light is the great transformer. It can work magic with what you might ordinarily consider an unpromising subject. And light can play never-ending variations on any given scene. Apart from its great power to endow a landscape with mood, light is of the greatest help in indicating the form and texture of a plane and of emphasizing the third dimensional qualities of a picture.

Shadows move across a surface and describe it. If you study and delineate their direction and the character of their edges, the planes upon which they lie will be defined. The long shadows of early morning or late afternoon are particularly helpful in depicting depth and substance.

It would seem that the landscape sketcher should be aware of a thousand and one things. This is so, but they need not overwhelm you. They will come in a progression, in a chain of experience. One aspect mastered opens the door to another. The end is out of sight and beyond prediction.

IV. Greenery

The outdoor sketcher usually confines himself to the green months of the year, which is understandable, but a pity. There is just as much beauty and just as much material available to the sketcher in late autumn, winter, and early spring; the only thing lacking is comfort.

Finding the Skeletal Structure

When the green months come we look upon a land disguised. Like drawing a clothed human figure, we have to be aware of what is underneath to draw knowingly. The land's anatomy hasn't changed, but it is veiled by greenery.

Grass, grains, flowers, weeds, and trees are all parts of the green veil. All are beautiful and of infinite interest and you should searchingly and lovingly draw their forms, but never forget that the forms do not exist in themselves; they spring from the earth. If you really sense this, your drawings will convey it.

Structure of Tree Tree structure in three stages: the trunk and branch skeleton, the foliage blocked in, the foliage modeled.

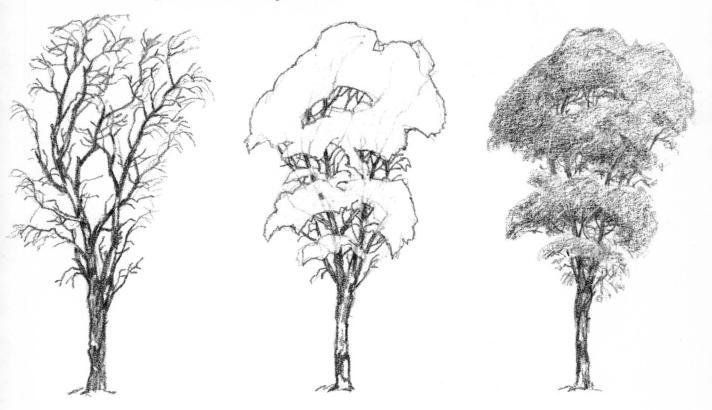

Take the case of the tree, perhaps the most beautiful of green growing things. It has a skeleton which you must understand before you can draw it correctly. The trunk is not just a post stuck into the ground, but the visible extension of a large anchor of roots, a clutching network that reaches an underground area about equal to the overhanging foliage mass. The trunk should be drawn with this in mind. Almost always you can see the spreading of trunk into root at the earth level and you should draw it that way. The shadow of a tree-trunk as it reveals the ground on which it lies is another important way of indicating the union of earth and tree.

As the trunk rises to the first breaking out of the boughs and the boughs reach out into branches and twigs, there is a general tapering of forms. This tapering network of the tree skeleton can only be studied clearly when the limbs are bare. Each tree species reveals special characteristics of growth: regular or erratic; up-springing, outreaching, or drooping; thick and sturdy, or slender and delicate. This trunk and branch pattern determines the look of the foliage and tree.

Branch Structure The branch is broken down into a series of tapered cylinders to reveal basic forms.

Drawing in All Seasons

Many artists draw and paint the fat foliage of mid-summer, not because the landscape is most beautiful or interesting, but because it is convenient. But the transition of foliage, its comings and goings, are of equal or greater beauty. From the bare tracery of winter through the first leaf-buds of spring, and the heavy green cloak of summer to the autumn glory of red, brown, and gold, the tree is made for the artist's pencil and brush.

Understanding Foliage

Foliage masses can seem baffling because they suggest infinite detail and at the same time elusive, impalpable forms. You can ignore the detail, but the seemingly elusive masses must be seen as forms in depths. Some trees develop into very simple forms, such as cones, or inverted cups, or a combination of interlocking cubes, cones, spheres, saucers, and other forms. Some trees are too irregular to fit any reasonable geometric pattern. But foliage masses have depth and projection as well as horizontal dimensions and this can best be seen in the low, side light of early morning or late afternoon.

Sketch in the main foliage masses, trying, at this point, to avoid being distracted by small or unimportant masses. The big masses

will have a general all-over tone in the light and a darker tone in shadow, but the darkest tones are in the pockets of shadow under the masses.

There is no standard way of indicating the all-over tones, and artists work out their individual methods. If you are in doubt, you may try the brush or pencil to suggest the general upward and outward growth from the trunk and radiating branches. This method emphasizes the natural growth of the tree: the arching vase form of the elm, the down curving arc of the weeping willow, or the horizontal reach of the dogwood. Some trees have closely packed masses of foliage, others are more open. Study the openings carefully, because they have a good deal to do with the character of a tree and they afford glimpses of the supporting boughs and branches. Do not indicate these limbs in a haphazard and stick-like manner; they should follow the rhythm of the tree's skeleton. The borders of the foliage and the edges where shadow breaks into sunlight are important. These borders need not be drawn in minute detail but their character should be suggested. Although you will seldom have reason to draw the entire outline of a tree with knife-edged detail, you might find that by doing so you will disclose a great deal of the tree's kind and character and prevent the tree masses from being too amorphous.

Detail Study A study of a spray of ground sarsaparilla; one of thousands of plants that grow, often unheeded by the artist's eye.

29

There are times when you should study and draw sprays or individual leaves, for knowledge of any form develops from studying both generalities and details. A day or half-day spent drawing a tree from varying distances should be a fruitful exercise for you.

It is very easy to slip into fixed habits when sketching out-of-doors. If you are fond of drawing trees, you may find yourself unconsciously sketching them always at the same distance. The tree is a challenging subject nearby, far away, and at all distances

Bolognese Drawing An Italian Renaissance drawing of the Bologna school. Here is a method of expressing foliage typical of that age. In today's search for new ways to express form, older ones such as this are often revived. Each age works out its own methods.

Andrew Wyeth Spring Beauty. A detailed study of root forms.

between. Nearby, the details of form and texture become more important. The trunk near at hand becomes more than a dark column in a retreat of shadow. The trunk reveals nuances of color and individualities of texture: the oyster white of the peeling birch; the soft cool gray of the beech; the smooth black bark of the cherry; the seamed and rutted trunk of an old oak; the mottled scabbing of the sycamore. The bark of young saplings is usually smooth, but with age comes the thickening, the warts, and fissures.

Foreshortening

The boughs and branches assert themselves more as you come closer, and you will become sharply conscious of the problem of branch foreshortening. It is the sign of the amateur to draw trees as though branches only grow sideways. Branches also retreat from and project toward you and drawing this foreshortening demands knowing draughtsmanship. The retreating or the advancing branch tapers from its junction to its tip but its direction is never a straight line. Some branches angle, curl, and change direction constantly; others maintain a general direction, but through a series of subtle

adjustments. It is these adjustments, slight or marked, that must be your concern. Basically, the branch is a tapered cylinder and if you visualize segments of this geometrical shape in each change of direction, you will solve the fundamental structure of the branch as demonstrated in the diagrams on this page. It is not necessary to draw each branch by this method, of course, only to be aware of it and so guided.

Drawing the Peripheral Objects

The tree is conspicuous and receives natural attention from the artist, but the lesser growths in the landscape are often neglected. The foregrounds of many landscapes are inadequate and unfulfilled. They betray an obvious lack of authority in the delineation of foreground elements. Grass, weeds, and shrubs are often items falling in this lower part of a picture, and although these elements often need only be freely suggested, *suggestion* is possible only through *knowledge*. *Knowledge* comes from *observing* and *recording*. So careful study of small forms develops the kind of close attention that can be translated into eloquent and knowledgeable brevity of execution. Slow and precise study is a foundation for swift suggestion.

The smaller plant forms are not only important as details to be studied, but for their own beauty which can be material for pictures in themselves. A mile-wide panorama is not necessarily a finer or more promising subject than a thistle or a clump of wild carrot. The small world under our feet contains inexhaustible subject matter. Microphotography is making us aware of a wonderful world of miniature forms. In fact, it would not be ridiculous if a landscape school should arise that would find its subject matter under a magnifying lens.

Confronted with the great accumulation of man's graphic recordings, you might believe that the last pictorial word has already been said about the natural world. The amazing variety in this accumulation proves the opposite: it shows the boundless fertility of man's observations. The more he assimilates, the more his awareness is sharpened, the deeper he sees into the familiar things of life. The natural world has not yet revealed all its secrets to the artist.

Henry C. Pitz Eucalyptus Grove, California. A mixed media drawing combining pencil line, pen line, and wash.

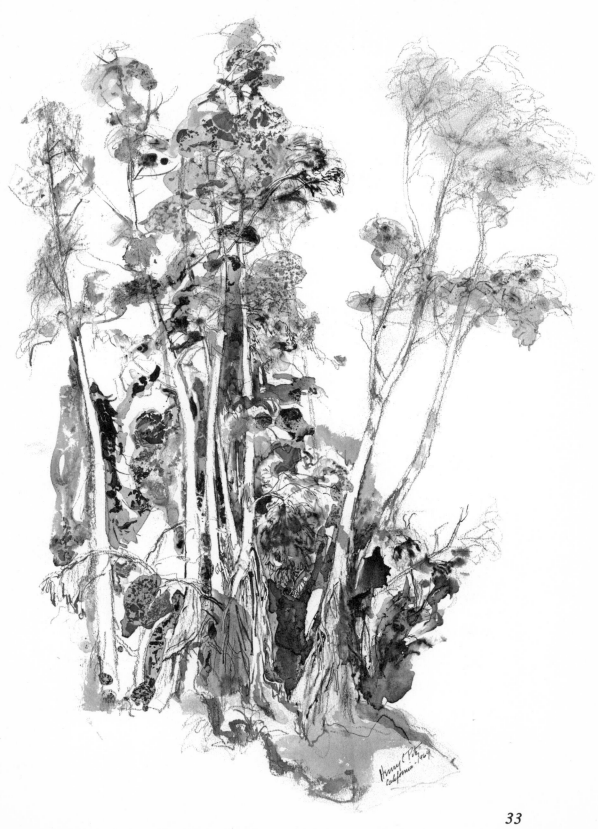

33

V. Skies

No part of nature's world requires the artist to be more of a nimble opportunist than skies. The only patient skies are cloudless ones, and some sketchers evade the problem of moving clouds by always pretending to draw on cloudless days. But the endless shifting drama of cloud forms is one of the great spectacles of nature, material which presents the artist with a powerful means of casting a mood.

Sketching Clouds Rapidly

Sketching a high mountainous cumulus cloud-mass on a seemingly windless day can teach you a lesson in sketching agility. The seemingly motionless mass melts and moves in every least part; no portion of it halts for even a few seconds. You can only work furiously, trying to capture the major shapes before your subject has revised its form. Here is where a sharp memory can help you supply important impressions of the original shapes after they have changed.

Using the Best Medium

The sketching media most suitable for rapid sky notations are charcoal, pastel, and wash. Charcoal and pastel sticks can lay in a tone and indicate form with relatively few, quick strokes, and tones can be reduced and forms modeled with a speedy rubbing finger. A kneaded eraser can pick out lights or remove unwanted tones or lines. You can sympathetically convey the blended tones of most cloud forms by these two similar mediums. Wash rendering requires more time to swing into action, but once prepared can be just as quickly responsive. Often the best way to delineate cloud forms is to paint *wet-in-wet,* by first dampening the paper with sponge or brush and then painting into the moistened surface. The edges will blend more or less depending upon the degree of moisture. You can use scraps of blotter, soft rag, or paper tissues to lift lights or modify forms.

When we consider other sketching media , we begin to realize

Henry C. Pitz A sky painted in monochrome wash. Sky and ground areas were covered with clear water and the color masses painted into it.

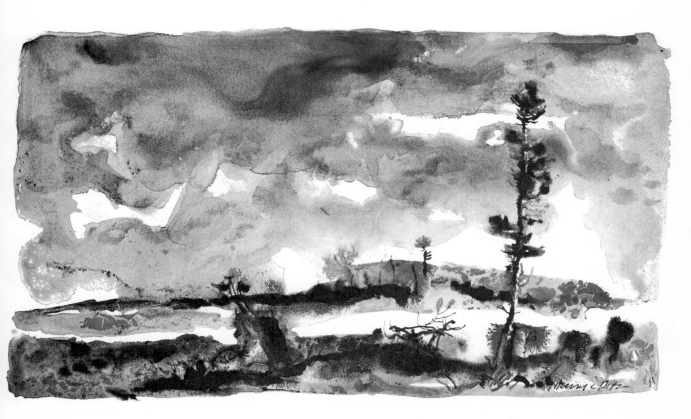

why sketchers so often allow white paper to represent sky. Pencil and some crayons are fairly nimble tools for drawing skies but the pen or brush line in ink is another matter. These tools produce a hard and steadfast mark which seems unfitted to describe the distant and impalpable qualities of a cloud. Certainly, it is asking a great deal of the ink line to delineate the subtle folds and billows of a cloud tower. And yet, the expert pen artist manages to tell the story of skies in his own way. He seldom tries for complete tonal illusion, an effect which would be possible in the case of a stormy sky where dark tones predominate. He usually resorts to artifice, to suggestion: a few broken outlines, a mere hint of tone, and a cunning adjustment between the rhythms of the sky and the landscape below. He does not try to match the tones of nature; he uses conventions. In short, he relies on a few basic tones and outline. This is working within the limitations of the medium and is gain as well as loss.

Henry C. Pitz Another landscape and sky, in which ink was painted into areas of water.

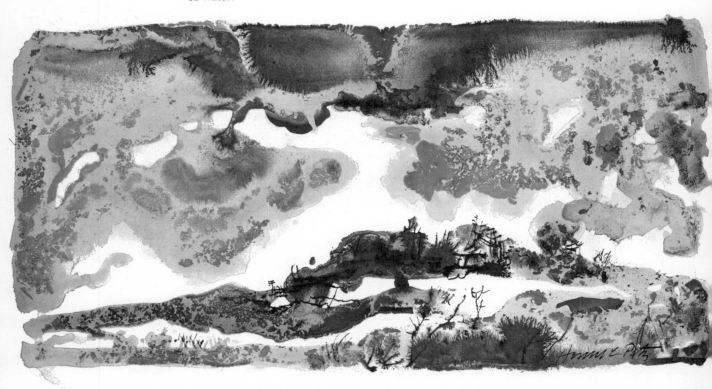

Henry C. Pitz A skyscape in pastel.

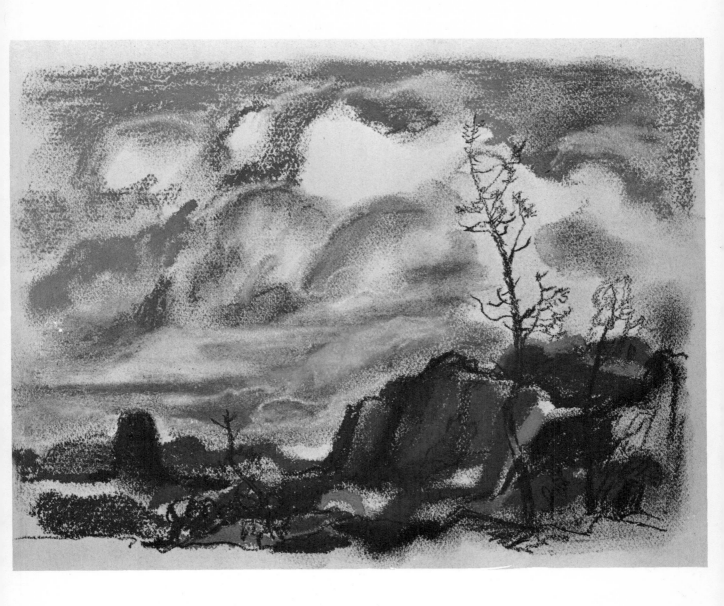

Interesting and unusual cloud formations must be taken when available and often without concern for the landscape over which they hover. A collection of sky sketches becomes valuable not only because it is evidence of your widening experience, but because from the collection many a sky can be adjusted to a future landscape. The artist soon learns that a proper sky can make a vital difference in a picture.

A knowledge of cloud forms and the effect of various sky lightings can greatly fortify your imagination and sense of invention. Having learned something of nature's resources, you can call upon one of her past performances to remedy a present deficiency. Adapting a remembered sky to a landscape before your eyes might turn out badly if your judgment were at fault, but with the wisdom that comes from continued observation and recording, you develop a sense of the appropriate. When the time comes for you to use the notations of your sketchbook to build a more considered composition in your studio, you will be exhilarated by having the authority of a stage manager, shifting lights and shapes, inventing realistic skies, and investing the whole stage with drama and mood.

As in dealing with all other facets of nature, drawing skies in a variety of media is a rewarding experience. Each medium requires certain adjustments of expression and this adjustment forces a renewed scrutiny of the subject. A command of drawing skies comes from piling up experience and when this command reaches a point where not only the fleeting forms can be adequately recorded, but skies can be transformed or invented to fit varying landscapes, the artist has reached the creative level.

VI. Buildings

If you can draw a cube from all angles, you have taken a long step toward learning to draw buildings. Buildings have many other shapes, mostly variations upon simple geometric forms, but the cube is the underlying form-factor in most architectural structures.

Finding the Horizon Line

We have talked about some bare essentials of perspective in a previous chapter; they become of more pressing importance in drawing buildings. When you face a landscape, the horizon line is not always easy to place exactly. It is on a level with your eye, but the average landscape is without positive horizontals to act as a check for the eye, so an approximate horizon is usually good enough. But the mathematical lines of most buildings demand a more positive decision. It is easy to find building horizontals above the eye that follow a line down to the horizon and similar ones below the eye which diagonal up to the horizon, but sometimes it

One Point Perspective One point perspective, the simplest kind of perspective, can be applied when the artist is squarely facing the frontal plane of an object (the façade of a building, for example). The planes at right angles to the frontal plane recede to a vanishing point on the horizon.

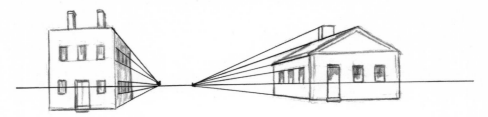

is more difficult to find the point at which the horizontal of a building coincides with the artificial horizontal of your horizon. Although the perspective horizon is an artificial line, it must be established, at least mentally, if the principles of perspective are to be applied.

One Point Perspective

Most problems to which these principles are to be applied can be solved by either *one point* or *two point* perspective. *One point* perspective is the simpler of the two and can be called into play when a building or line of buildings runs parallel to the plane of your picture. The sides of these buildings recede from you toward a common vanishing point as demonstrated by the drawings on these facing pages.

Two Point Perspective

Two point perspective is necessary when a building is at an angle with our line of vision (the picture plane). Now both visible sides of the building recede to different vanishing points, but on the same horizon. If the building is placed so that the two sides recede from you at exactly the same angle, the vanishing points to the right and left will be equidistant from the corner. The more sharply a side recedes, the less you see of it, and the closer in the vanishing point will be. The demonstration drawings should be studied until the principles are understood and then you should put them into practice in your own drawing.

Two Point Perspective These two drawings demonstrate two point perspective used when the artist is facing planes at an angle. In the first drawing, the artist is facing the corner of the building and the two sides recede at about the same slant. In the second drawing, the artist sees more of the front than the side, so the vanishing point of the front is farther away on the horizon and the vanishing point of the side is closer.

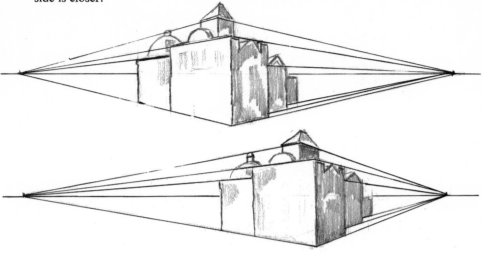

One way to start, if you have a convenient window that looks out upon a building or buildings, is to draw the structures upon a window pane with dark chalk or pastel. To do this successfully, you must hold your head immovable, for the slightest change of focus alters all relationships. Trace the principal lines of the building on the glass. With this as a guide, you can make a more complete drawing on paper from exactly the same view point.

Locating the Vanishing Lines

When you are in the field sketching buildings, you must estimate the slant of converging lines. First, always find the horizon. Holding up your drawing board or sketching pad to eye level and as close to a true horizontal as possible, raise or lower the pad until some architectural line coincides with the horizon. That is the horizon line for your vanishing points. Often there will be no prominent architectural line at this point; you will have to search for a line of masonry, a course of bricks, the top, middle, or bottom of windows, or even estimate its position between two other converging lines. Remember that vanishing points often find them-

selves far outside the limits of a drawing, so estimate them from the beginning. This may sound difficult, but the whole purpose is to develop observation and judgment until the day when these things will become instinctive. At first, it is a fruitful exercise to place a tracing overlay over your sketch, and work out the vanishing lines in a diagrammatic analysis when you return to your studio.

Although most problems can be solved for the artist by the one or two point methods, a thorough application of perspective to most problems would result in multiple vanishing points. A case in point is the common situation in which a straight street changes its levels. The buildings lining the street may still keep their common vanishing points, but the street requires a new vanishing point for each change of tilt.

Underlying Forms

We come back to the idea that a knowledge of the simple cube form in all positions is the foundation for delineating buildings. A wooden cube, or a paper box is not difficult to procure and, drawn in different positions, can serve for an endless series of finger exercises. Doors, windows, and cornices may be drawn upon the cube to make the relationship clearer. When you face a group of buildings, you will spend some time in analysis, trying to find the big underlying forms. This often involves mentally eliminating subsidiary excrescences and refusing to be distracted by detail. The detail may be of great interest and you have a right to explore it, but first prepare the foundation to which it is attached.

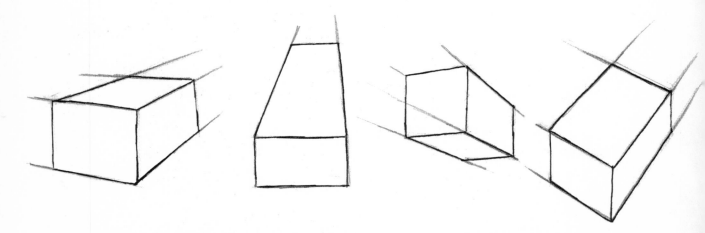

Box Buildings Box shapes drawn from all angles will train the eye and hand to see and depict basic building forms.

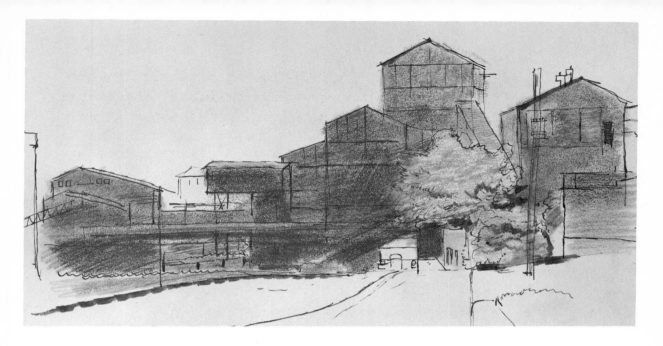

Peter Helck Factory silhouettes. A mixed media drawing combining pen line with pencil and color chalk.

Sherman Hoeflich Old Houses—Nice. A study in ink line with freely applied washes of color.

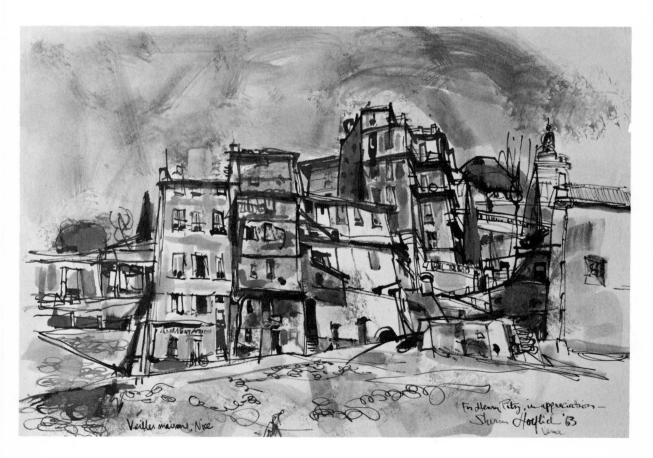

Ernest Watson Zermatt. A drawing executed mostly with chisel-pointed graphite pencils of varying degrees of hardness.

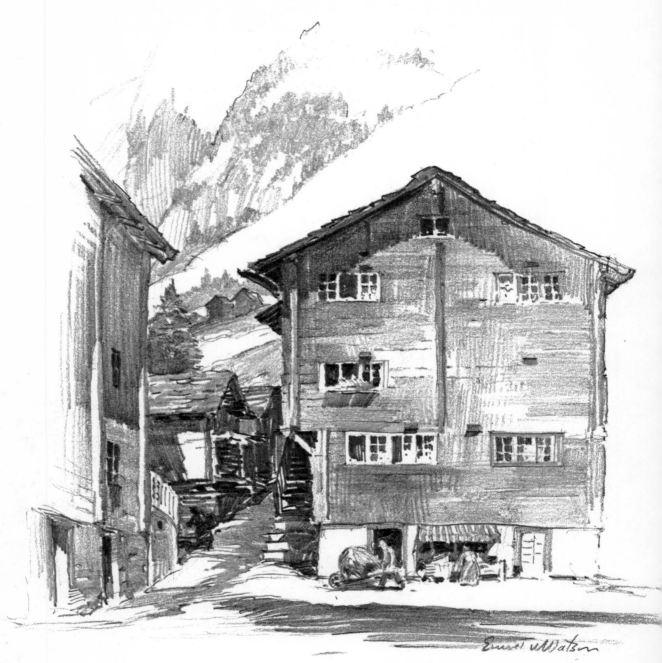

ZERMATT
SWITZERLAND

You may choose to draw architectural detail with great completeness, and every artist should have this as part of his experience, but for general statements there is much that can be told by pictorial suggestion rather than by long and laborious statement. For example, you may wish to convey that a building is made of brick, but it would be unnecessary for you to draw every brick. A few bricks, suggested in significant parts of the building, will convey the message to the beholder. Windows and doors need not be enumerated; a few, deftly done, can be a symbol for the many.

As your sketching enlarges through practice, new factors reveal their promise. For example, strong light and shadow not only become valuable for defining surfaces sharply, but the endless patterns they create open up a new world for expression. The shadow

Norman Kent A bold architectural study made with a nylon tip pen.

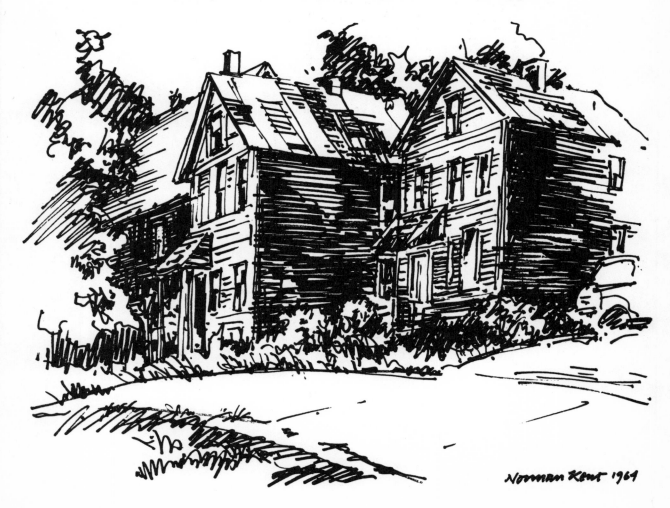

shapes cast by one building upon another help explain both the surface upon which the shadow lies and the form which is casting it. Textures reveal themselves—brick, stone, concrete, synthetic panels, wood siding, tin roofs—all with their separate characteristics. Age and newness can be expressed. Substantiality or flimsiness can be conveyed in a sketch.

An interest in sketching buildings can lead to related interests, such as a study of the architectural styles of the past and present, an interest in methods of construction and building materials. You can scan architectural magazines and building journals. Anything that enriches your background shows itself in your drawings.

William A. Smith Gaw Wein Seik—Mandalay.

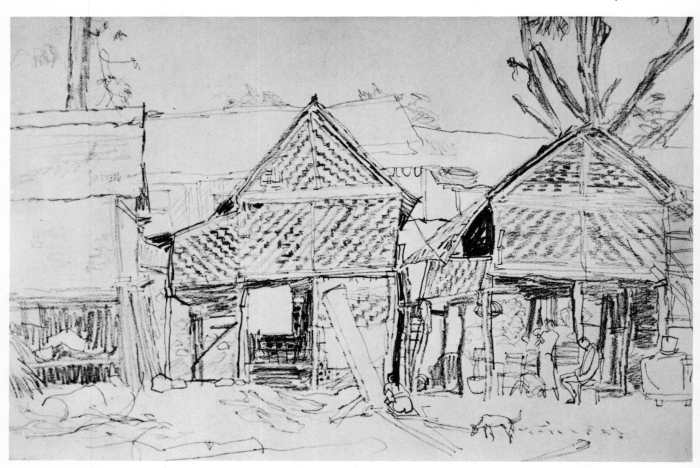

Bill O'Donnell Victorian House. Courtesy, Pisani Prints, San Francisco.

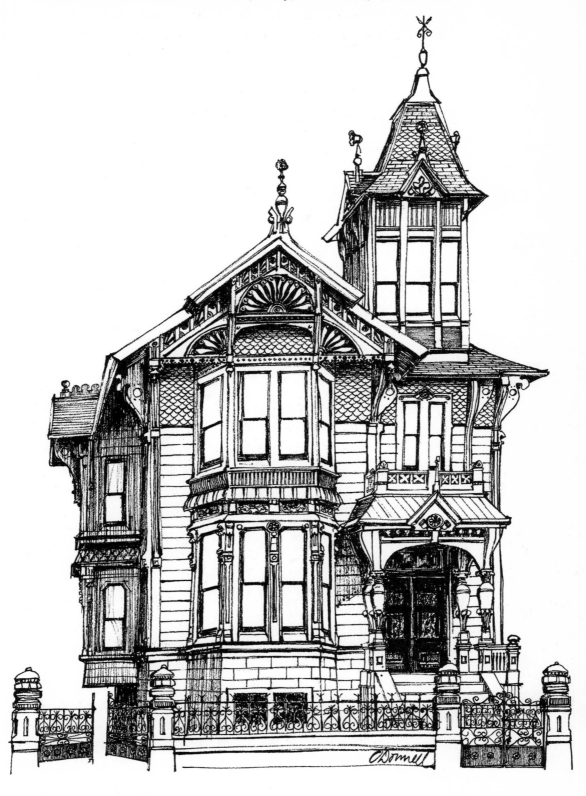

VII. The Urban Scene

The artist often approaches the urban scene with ambivalent feelings. He may have a strong distaste for its mindless clutter, its hasty, jerry-built monuments to greed; its noises, smells, and inanities, but he feels its fascination too. He may find the city tawdry and repellent, but it has the appeal of all things bursting with vitality. Besides, the urban scene is one of the most obvious and insistent expressions of our age and it challenges the artist to acclamation or rebellion.

Acclamation and rebellion are ancient motivations of the artist and they may spur him to masterpieces. The contemporary urban scene has not attracted any large number of artists and yet it is an enormous field, relatively unexplored in spite of the familiarity. With the latest veering in the cultural winds—away from abstraction and toward the rediscovery of worldly forms—it is highly likely that an eloquent school of urban painting may arise, using the baffling and protean forms of the modern city to record the story of our twentieth century close living.

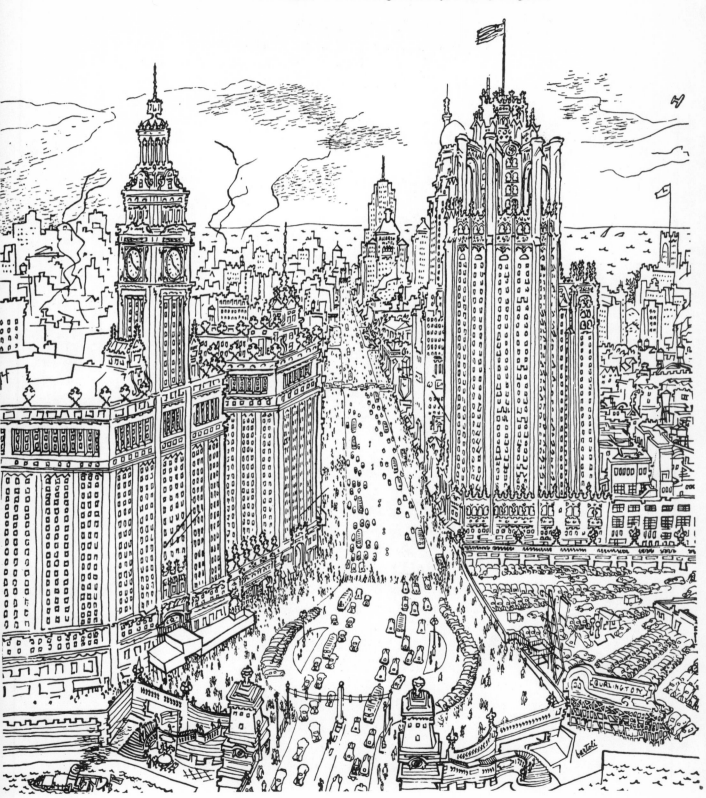

José Bartoli Pen drawing. Courtesy, *Holiday* Magazine.

Seeing the City in Cubes

For many, the city is at the doorstep with the most accessible material for picture-making. It is largely cubistic material, an infinite interplay of cube-like forms. The horizontals and verticals predominate. These basic units take a thousand forms; the towering cubes of city centers squeezing older, sagging cubes between them; countless window rectangles, doorways, signs, tanks, shafts, and poles common to almost all American cities. Often there are older residential streets, tree-shadowed with lawns and older houses, ample, Victorian, and showing the patina of time. Sometimes these neighborhoods are trim and furbished; sometimes in stages of neglect and decay, but always pictorially interesting. There are usually parks and playgrounds, a few grudging open spaces, some imposing public buildings, trim suburbs, monotoned slums or near slums,

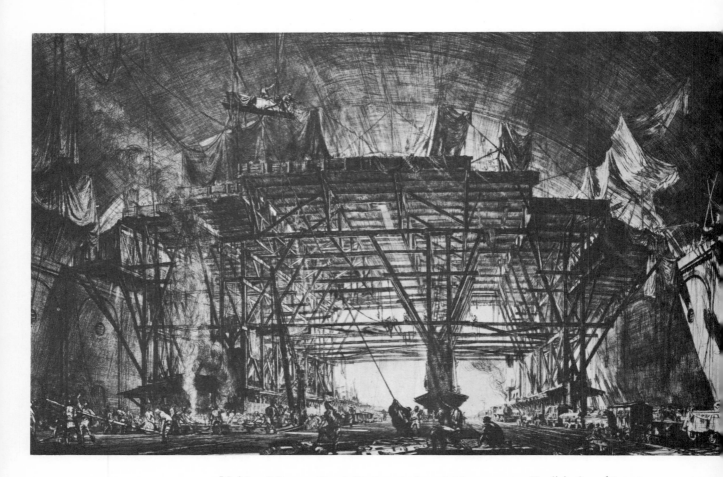

Muirhead Bone Great Gantry. A drypoint by a master English draughtsman.

Henry C. Pitz Venice. Drawn with crowquill pen from a hotel balcony.

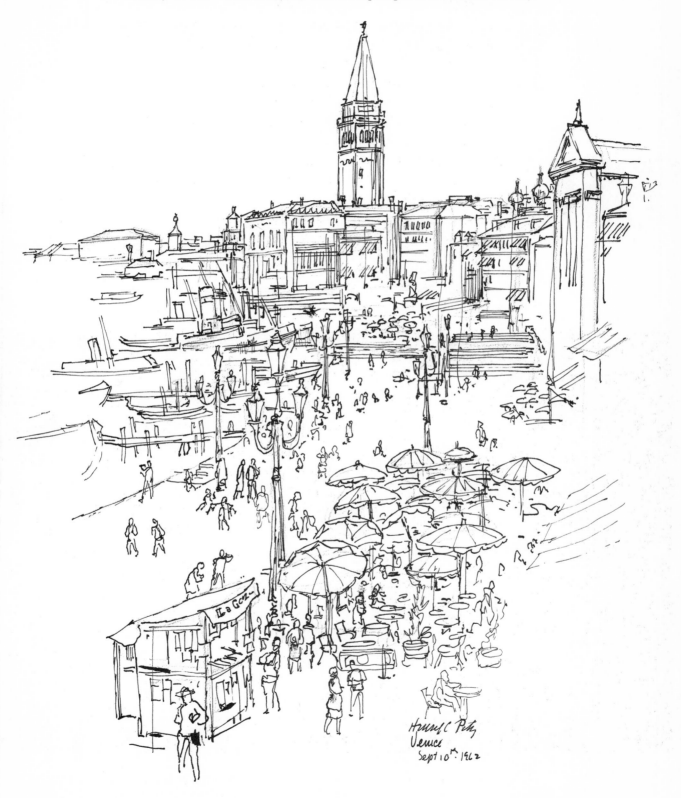

George Bellows Evening Snowstorm. This lithograph combines passages executed with a crayon and with a brush.

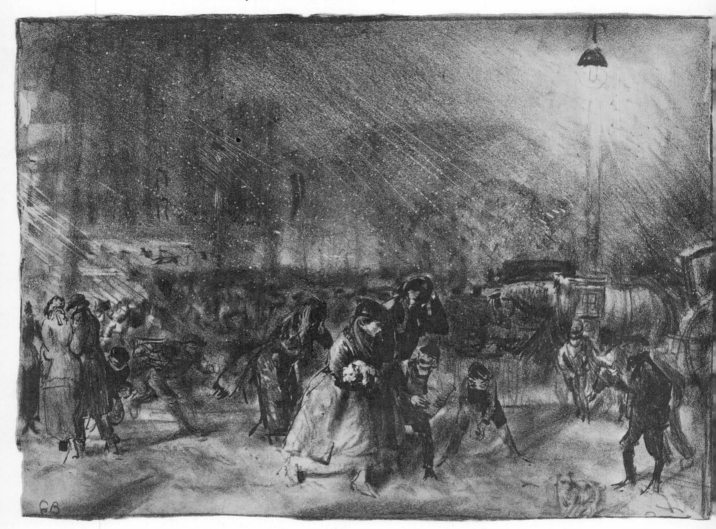

motor highways, bridges, parking lots, shopping centers, new and old factories, and the inevitable periphery of commercial clutter. The catalogs of most American cities are only too similar.

Drawing People in the City

Threading through all this sprawling warren are its reasons: people. They seldom emerge as individuals, usually only as units of a group or crowd. The urban delineator must learn to depict crowds. It is hopeless to depict a crowd by attempting to draw each individual in it. The artist must lean heavily on suggestion. A group

or crowd will have a general shape (observation will discover this) which should be indicated lightly, for a crowd is a fluid mass and you must be careful not to draw in too confining a way. The inner mass of a crowd is usually a moving ferment of indistinguishable forms, but on the edges you can pick out some characteristic shapes: hats and heads above, legs and feet below, and on the outer borders some arms and bodies. If, in some focal point of the crowd, you indicate a few figures with more precision, you will be surprised how the eye will tend to multiply them and assume that the crowd mass is entirely composed of such figures.

True enough, there are city and town views in which the individual asserts himself, but more often he is dwarfed by his creations, not only by size, but by color, clutter, and fantasy of shapes.

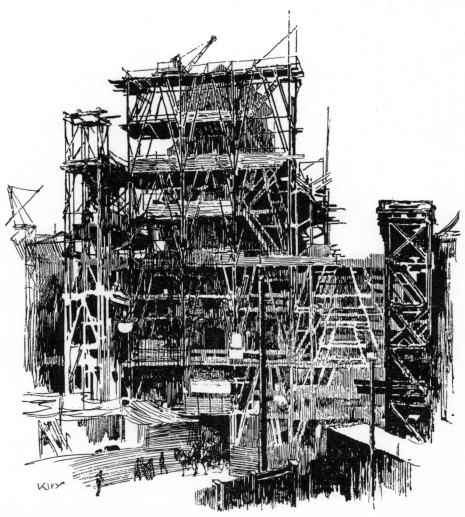

Heinrich Kley Construction. A pen drawing with virtually all the tones interpreted in vertical strokes.

Basically, the individual is surrounded by geometry—a world of cubes, cylinders, prisms, globes, pyramids, triangles, rectangles, circles, and squares.

Using Perspective

Immediately, the problem of perspective arises. The same elementary perspective that we have learned in dealing with a separate building in the preceding chapter can be applied to our city views. At first, the problem may seem hopelessly complicated, but without blinking at its difficulties it can be subjected to simplification. Often the essential perspective of a forty-story office building is no more

Ben Eisenstat A pen drawing of a Yorkshire industrial town.

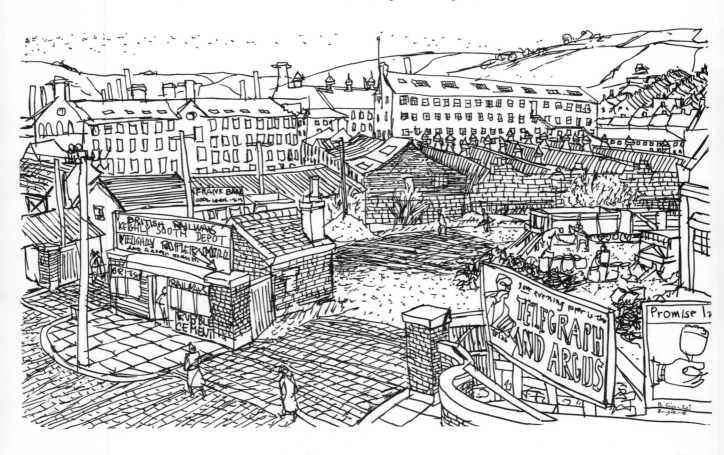

complicated than a two-room shanty. Buildings can often be lumped together in one all-inclusive mass and, since most American streets are straight, the same vanishing lines can serve for all buildings on the length of each street.

Seeing Clarity in the Confusion

The knack of seeing the simple, all-enfolding shapes that are the basic forms for large numbers of buildings is usually not easy to come by, but like other problems of drawing, patience and persistence can open many doors. All through the problem of drawing architectural forms runs the factor of simplification. What of the

Ronald Searle　A pen and wash drawing from *Paris Sketchbook*. "Perpetua."

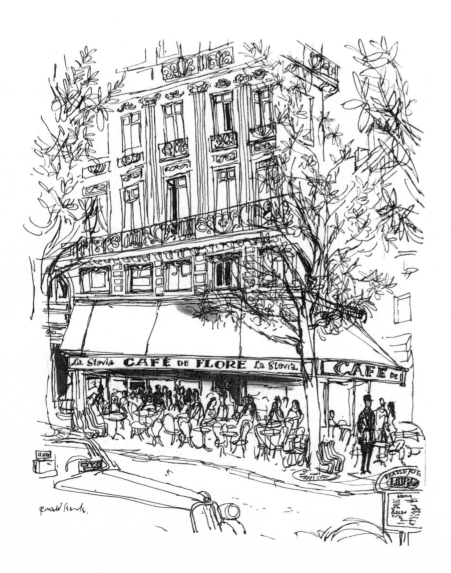

office building with hundreds of windows? Should you draw all the windows? Not unless there is reason for a minute and detailed study. A hundred windows can be suggested by spotting possibly six or eight in places where the eye will find them easily, supplemented, perhaps, by a few lines or spots suggesting other windows. The same approach can be used for other details, doorways, cornices, panels, columns, steps, and moldings. The artist learns not only to use his *own* imagination but the imagination of the people who look at his drawings.

Much of the character and fascination of the American city derives from its clutter: the superficial trumpery that decks and partly masks the structural forms behind; the wilderness of signs of every size, shape, and color; poles, wires, banners, gasoline pumps, telephone booths, letter boxes, light standards, not to mention the parked and moving automobiles, the highway stripes, the billboards. Alphabet characters dance everywhere in all colors and distortions. Words flash and wink; giant images bludgeon the eye. This is our daily optical diet and we are hardened to its pictorial confusion. But it is a unique and fertile field for the artist who has not grown callous to the familiar scene and is excited by its great possibilities.

A factual report of its incredible forms drawn in the traditional manner could yield a document of great interest, but to get at the frenetic heart of it, an infusion of the modern idioms and freedoms is almost obligatory. Here is new subject matter which, if not untouched, is certainly not extensively cultivated. It could nourish a flourishing school of painters and graphic artists capable of subduing our crazy-quilt civilization into memorable patterns.

VIII. People

Human beings have been the artist's major subject for ages and if the modern sketcher concerns himself with inanimate nature alone it is usually because he is frightened by the difficulties of drawing the figure. The human figure is difficult by comparison with many other objects, but it is not beyond the powers of most. Drawing the figure demands intelligent effort and lots of practice. A certain price of concentration and dedication must be paid, but the rewards are rich.

Where to Find Your Model

The outdoor sketcher can choose from a multitude of models but he cannot control them. They offer him countless opportunities, but usually only in snatches. They give him the widest variety of shape, character, and pose, but only on their own terms. So the artist who is hunting people with a sketchbook must be a nimble opportunist.

You will seldom have time for a plodding, measuring, second-guessing approach. You will usually have to make quick judgments and quick motions, for better or for worse. Experience will teach

you certain strategies of approach. You will discover favorable times and places.

People are almost everywhere, but they are not always in advantageous places for the sketcher. You need some kind of haven or vantage point. True enough, you may choose to sketch openly in the busiest places—there is no better way if you possess more than usual powers of concentration and fortitude. But doing this invites curiosity, comment, and others forms of distraction and even interference. Moreover, the people you are drawing become resentful or self-conscious. In either case, their value as models is diminished, for you are seeking the natural and unconscious.

Drawing Inconspicuously

For most artists, a certain amount of concealment is helpful. Concealment doesn't necessarily mean *hiding,* it merely means being *inconspicuous*. It means finding a place where you will not be brushed or bumped—a doorway, a park bench, a balcony, a corner. It means slipping the pad inside a book or newspaper. It means inconspicuous motions.

The usual practice of continually moving the gaze from subject to paper is likely to attract attention. A new and useful tactic should be developed, a seemingly disinterested appraisal of the subject, followed by drawing until the results of observation have been recorded. This tactic may be repeated as many times as circumstances permit. In addition to attracting a minimum of attention,

Henry C. Pitz Sketch with felt tip pen.

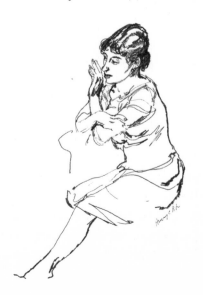

William A. Smith Pencil drawing from Japanese sketchbook.

it is a most valuable drill for sharpening your observation and storing your visual memory. It is excellent for recording figures in motion.

Drawing the Figure in Motion

There are two methods of drawing moving figures, both of which should be developed. One method is to watch an action move through its phases and attempt to record it as you watch. All you can hope to set down are a few lines of action and then another hasty series as the action passes into another phase. This can be continued as long as the model is in sight or as long as you have stamina. These fleeting bursts of delineation should be a most rewarding drill. They require fierce concentration but they impress images of bodily actions on your mind and stimulate your hand to rapid coordination. It is a method of attack that should be practiced by all who wish to command drawing the figure.

But the second method should be practiced as well. Scrutinize the figure to impress its image on your inner eye; then turn from it and draw the pose until your retained information is exhausted. This is the method which is less likely to attract the attention of your neighbors. There is no question of one method being superior to the other; they complement each other and should be practiced alternately.

Simplifying the Human Figure

To help your eye find simplicity and essentials in the complexities of moving or briefly posing figures, it is helpful to hark back to elementary concepts. Everybody knows and has probably practiced the stick figure, similar to those shown on these pages. Stick figures are not just a kindergarten product; they are human figures reduced to simple armatures. There may be little feeling of bulk in this armature, but the stick figure can express action. And the sketcher in haste can learn something from its simplicity. The line that represents the spinal column is of great importance. It is the most important indicator of the body's actions. Whenever the action of

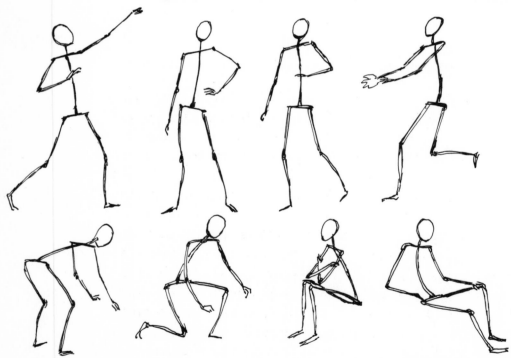

Stick Figures The stick figure is child-like, but it reduces the human form to its simplest essentials. For those seeking to record human action in brief time, it offers many clues to rapid notation.

Advanced Stick Figures A development of the stick figure toward greater solidity.

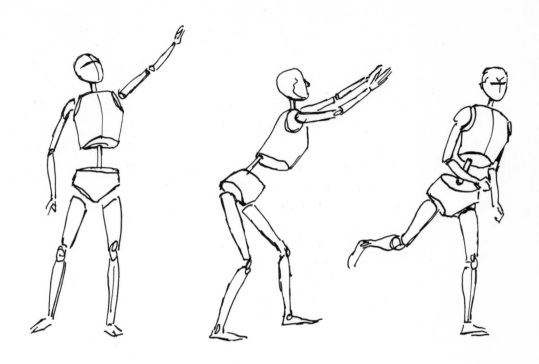

the whole body or the torso is a puzzle, try to work out the position of the spine. Linked with it are the two cross-bars, the lines of the shoulders and hips. With these three axes correctly established, most major actions of the body are on the way to solution. Remember that the pelvis is a heavy bony mass that makes the hips act together as a unit. The shoulders, although they often act together, are capable of separate motions.

Learning a lesson from the simplicity of the stick figure does not mean that we should apply it literally; only its principle. The sketcher working against time learns a pictorial shorthand of his own as he continues to practice. He does not rely on outline alone, or the axis lines of the stick figure, or on the leading lines of drapery action. He seizes any or all of these clues as he expresses a pose. He looks for the big swing of a figure, its important indications of bulk; the significant character of its clothing. His lines may define a form here, indicate an axis or imaginary armature there and then express the direction of a leading fold.

Henry C. Pitz Page from a sketchbook of fountain pen drawings from Turkey.

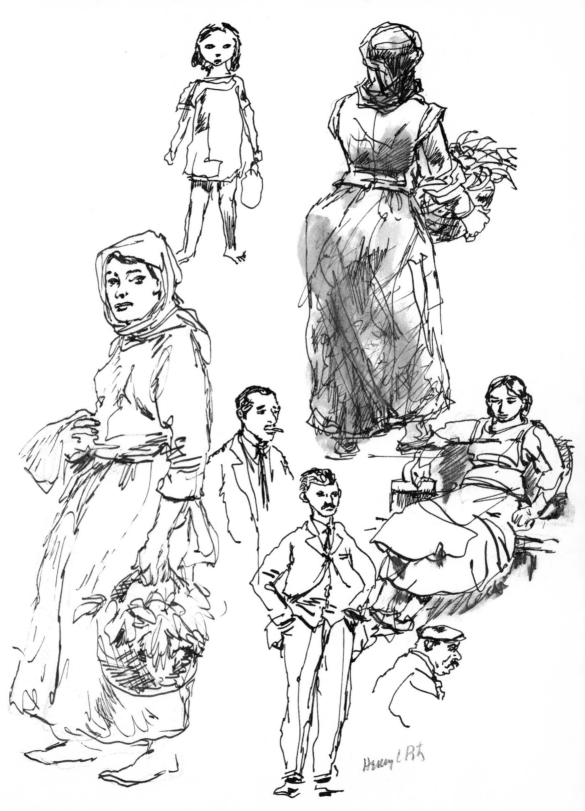

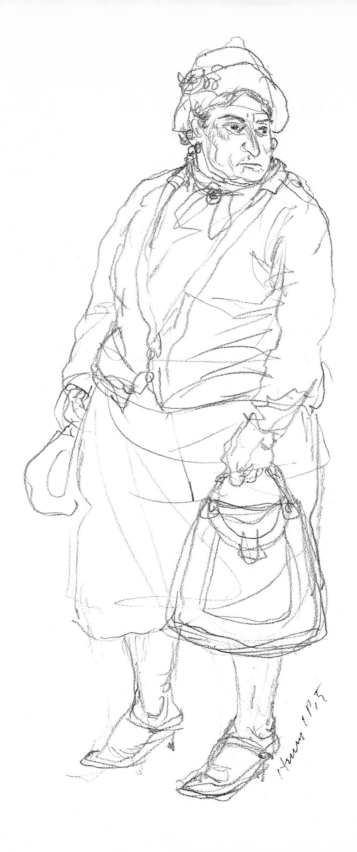

Henry C. Pitz Pencil drawing.

The End Product

Exact precision is not often possible at the beginning of such a sketch, but the first lines are left and modifying ones added. Often the sum total of tentative and more accurate lines expresses movement better than a more meticulous drawing. When you search for significant forms with your hurrying pencil you will find that you seldom lift the point from the paper's surface. The resulting drawing is a web of lines, a pictorial calligraphy.

All this calls for a special type of draughtsmanship, but a level of competence is not expected overnight. First efforts may be disappointing, particularly if you are holding in mind an ideal of a highly finished and smoothly rendered drawing. You are doing another kind of drawing, trying to express in perhaps a half dozen lines the posture and character of a human being. It is a brief note, not a mulled-over study. Gradually, through practice, the eye sharpens and the hand responds more knowingly. The eye finds things it had never known before and the hand discovers new capabilities.

Henry C. Pitz Quick pen sketch.

IX. The Gamut of Sketching

It is easy and sometimes necessary for the sketcher to slip into a narrow range of subject matter and method. But it is wise to become aware of the wide gamuts of the sketching world. Some may find a restricted sense of comfort, but most will be stimulated by the wide stretch of opportunities that can open up.

All four facets of the artist's repertoire—medium, method, time, and subject matter—offer wide territory for adventure and exploration. Although complete coverage would be impossible, you should be conscious that the borders of your own experience are narrow compared to the vast empire of art. But you can enlarge your own borders.

Your Medium

I will discuss the more usual monochromatic sketching media a bit later, but the subject of medium is by no means ever exhausted. Nor do I advocate that all these media be attempted at one time.

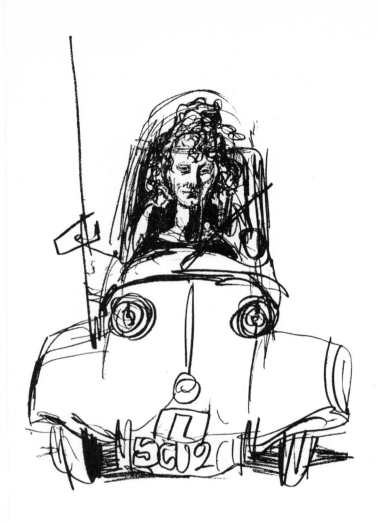

Feliks Topolski Pen sketch from *London Chronicle*.

This could end in confusion and disillusion. Not much benefit can result from a hasty sampling of each medium. The medium must be explored in depth, beyond the point of momentary discouragement, for no medium is automatically easy. The medium must be conquered by effort and practice; ease is the well-earned reward of persistence. It is sensible to acquire some command over two complementary media: a line medium and a tone medium, such as pencil and crayon (line) and wash (tone); or pen and ink (line) and charcoal (tone). Each can be used separately or in combination. By having differing qualities, they can offer a more rounded experience. In the end, the choice of media is a personal one, but should be based on periods of experience rather than hearsay. As you work and grow, your ideas about specific media may change; one medium may displace another as favorite.

Your Method

In the long run, methods too, are personal. That a method is and should be abandoned is no disparagement of it. The method may have served as an invaluable stepping-stone to something more fitting to your growth.

The method of beginning a sketch with light, tentative lines and tones and gradually becoming more emphatic and definite is a method that is excellent for both beginner and expert. But the expert, with the confidence of experience, may draw a definite line even from the beginning. And there is no reason why the beginner should not try drawing this way from time to time as a check on his ability.

Roy M. Mason Pencil drawing of shrimp boats.

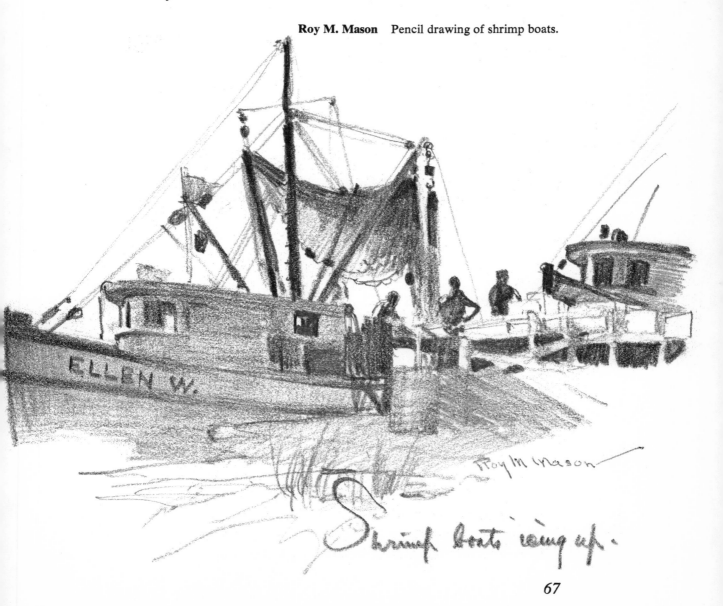

Peter Helck Gravel Pit—Amenia. Pen drawing on toned paper with shadows indicated in soft pencil.

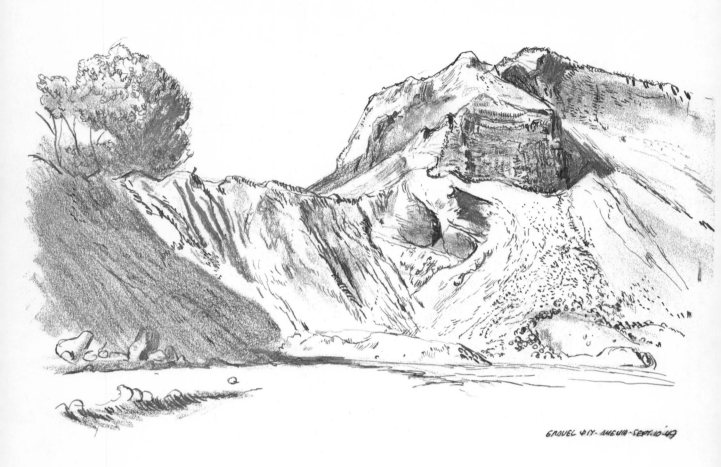

The method of beginning at the picture's core of interest and radiating out from that core is a most natural and intelligent method. Sometimes, however, it is convenient to begin somewhere on the periphery and work inward. Sometimes an artist may begin in some unimportant area of his picture, using it as a *warming-up* space before moving into more critical areas. There can be many small exceptions to every method but that does not weaken the validity of the method.

Henry C. Pitz Page from Grecian sketchbook.

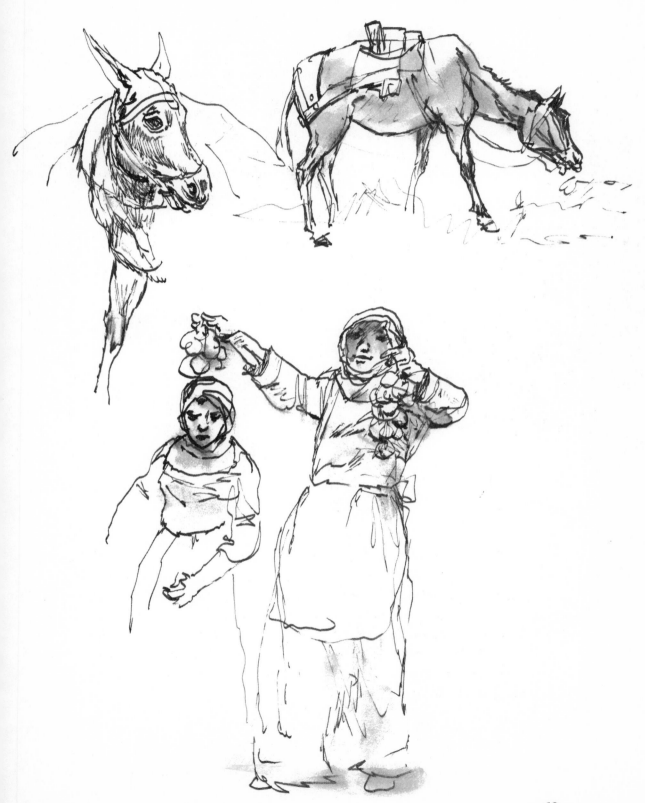

69

Your Time

Time is a factor in every picture and as an outdoor sketcher your time may vary from a few minutes to a long day. This wide difference in time powerfully influences the kind of picture you will draw. A few minutes can only produce a minimum of swift, telling lines; using a whole day, you can choose between many short sketches and a careful and fairly ambitious study. Many beginners gravitate toward a sketch (often more complicated than necessary), which will consume about an hour's time. They shun the very rapid sketch because it is too tense and the results are seldom showy. The begin-

William A. Smith Pen and ink sketches of frogs.

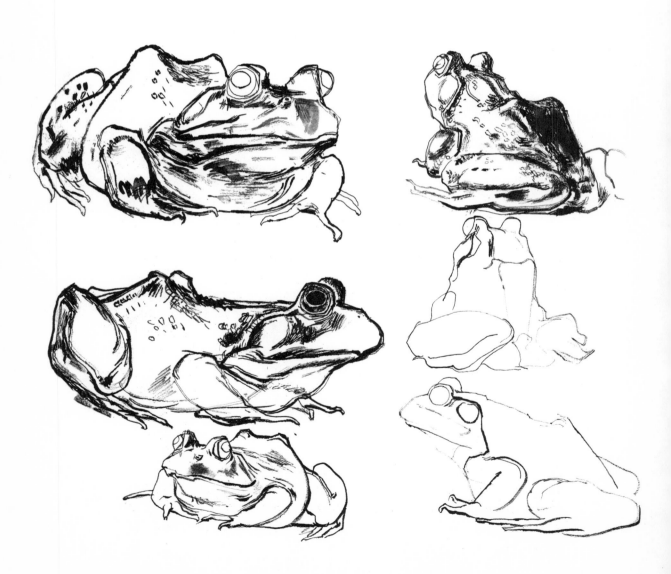

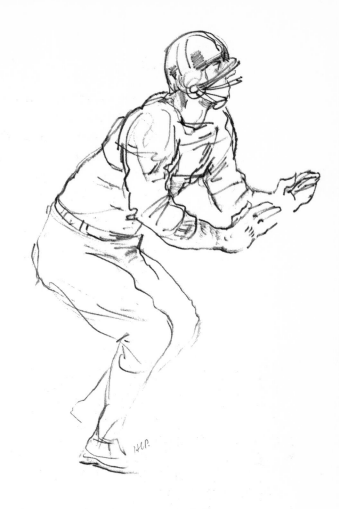

Henry C. Pitz Nylon tip pen sketch of football player.

ner also tends to shun the half-day or full-day study because his powers of observation and delineation are exhausted in about an hour's time. Both the very brief sketch *and* the extended study are experiences that you should not miss. They each contribute something indispensable. It is valuable experience to cram as much as possible into a few busy minutes. It is equally valuable to work persistently upon a drawing past the point at which you feel your knowledge and patience have been exhausted.

Your Subject Matter

Everyone seems to have favorite subject matter. Sometimes favorite subject matter springs from a poverty of choice. More experience, more investigation, might have turned up equal or superior subjects. Even your favorite subject can often be seen in a new light by comparison with other subjects.

There are always popular subjects and neglected ones. Artists are prone to follow each other and the current artistic fashions. Even with the whole world to draw upon, it is still difficult to do what is not being done. One inhibition, often difficult to overcome, is the conception that the subject should be sizeable and showy to be worthy of a picture. We walk past and are oblivious to the possibilities in a rain puddle, a fence-corner, a tree-stump, or a clump of rocks. Focusing more closely on the ground we walk over, we find a small and wonderful world of moss, stones, lichens, grasses, roots, and small blooming things. We often become solely sunshine artists, not only confining ourselves to the brilliant hours of the day and neglecting the long shadows of early morning and evening, but turning our backs on a gray, rainy or misty day. In the earlier years of this century, a large school of American painters revealed the beauties of snow to us, but they have had few successors.

One conspicuous phenomenon of our age, for example, is the

Andrew Wyeth Haying. Dry brush and wash.

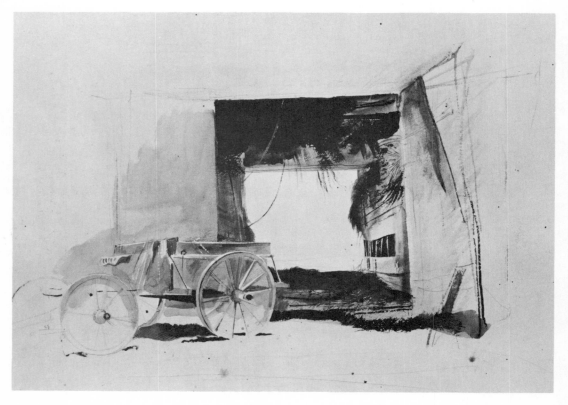

glitter and dazzle of our urban nights. Our streets and buildings are drenched in rainbow colors. We walk through a criss-cross of lights and penumbras: a fantastic world that has never existed before. As a subject, this has certainly played some part in stimulating the abstractionists, but the realists have made little response.

Although the machine has captured our age, the artist's response has often been to flee from it. But its mechanical shapes and surfaces are everywhere. They intertwine with and challenge the fluent forms of nature and provoke the fascinations of a new landscape. The artist is forced to consider mechanical shapes, even if only in rebellion.

Most artists are tied to some kind of orbit and the problem is simply to explore that orbit. Investigation is certain to turn up more material than seemed possible at first thought. You can always find the beginning at your own doorstep and then, by allowing one thing to lead to another, you can be led into unexpected paths.

Henry C. Pitz Pen drawing, some areas smudged with finger while the line is wet.

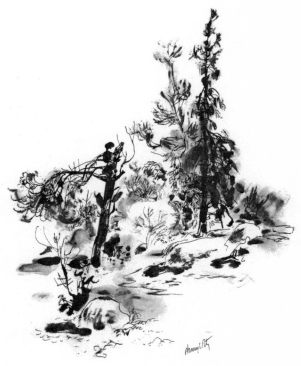

X. Pencil and Similar Points

Pencils are so familiar to us that they seem a natural tool. There is no other tool more convenient or less bothersome, features which put the pencil high on the list as a quick sketching instrument. The pencil is such a familiar friend that it might seem superfluous to say anything about its characteristics, its possibilities or its handling. But there are many kinds of pencils and kindred points and each variety has some influence on the resulting drawing.

Graphite Drawing Pencils

The graphite drawing pencil, as manufactured for artists, is classified according to degrees of hardness or softness, usually ranging from the hardest at 7H to the softest at 6B. All the degrees have their usefulness but for sketching, particularly the rapid sketch, the softer varieties are generally better. They glide over the paper with more ease and make a more responsive line. They indicate shadow and local color areas more readily. The hard varieties are

excellent for careful outline study and more meticulous rendering.

Graphite also comes in heavy leads without the wooden shaft and in square sticks. These work well for large, free drawings with masses of grays and blacks, for not only is the stroke heavier and wider than that of the ordinary pencil, but the side of the stick may be used to cover large areas quickly.

Dry Points

The so-called *carbon pencils* are favorite sketching instruments They are capable of producing a blacker line than graphite, and also have a dryer, more crumbly character. The famous Conté crayon, in black and sanguine, has been the instrument of many masterpieces of draughtsmanship. It, too, has a dry and somewhat crumbly line, but whatever its formula may be, Conté has an ingratiating character that has made it a favorite with artists for years. There are a good many varieties of the so-called *dry* type of crayons and pencils on the market. Some have slight differences of character but most of them produce about the same effects.

Lithographic Pencils

Of the points made with a wax base, the most widely used are the lithographic pencils and crayons. They come in several degrees of hardness and the harder varieties are more satisfactory for most uses because the softer grades will not hold a point. Besides the pencil form, they come in square sticks which produce interesting effects when you sweep the sides across the paper. They make very

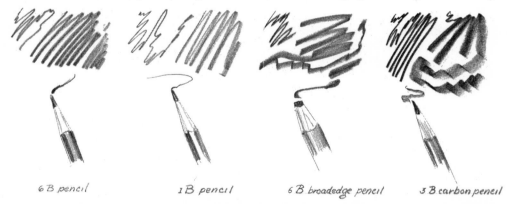

6 B pencil 1 B pencil 6 B broadedge pencil 3 B carbon pencil

Pencil Leads The size and quality of lead play an important part in the type of line or tone obtainable. Here are a few examples. You should make your own experiments changing not only pencil and crayon points, but trying various paper surfaces as well.

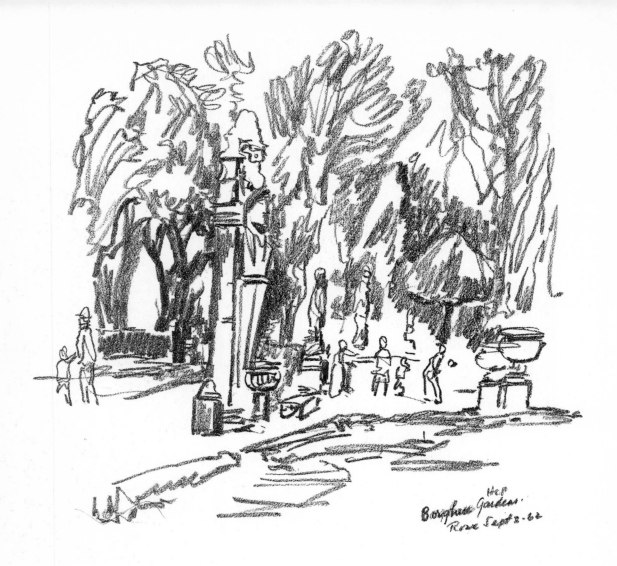

Henry C. Pitz Borghese Gardens. Sketch in carbon pencil.

black marks and, when used on textured papers, quickly produce areas of speckled tone. The lithographic mark blends very well with the ink line. One of the reasons for its widespread use is that it photographs sharply and reproduces well on line plates. The ordinary, inexpensive wax crayons that we associate with children's picture-making are not to be despised for adult sketching. Particularly when media are being mixed they are often used to blend with and give color-texture over watercolor or casein washes.

There are various kinds of holders available for the numerous makes of stick leads and crayons. All of these pencils or crayons fall into the category of the easy-to-carry and are readily available to the sketcher. The wax-based varieties will not rub, but you should protect the dry types with a spray of fixatif.

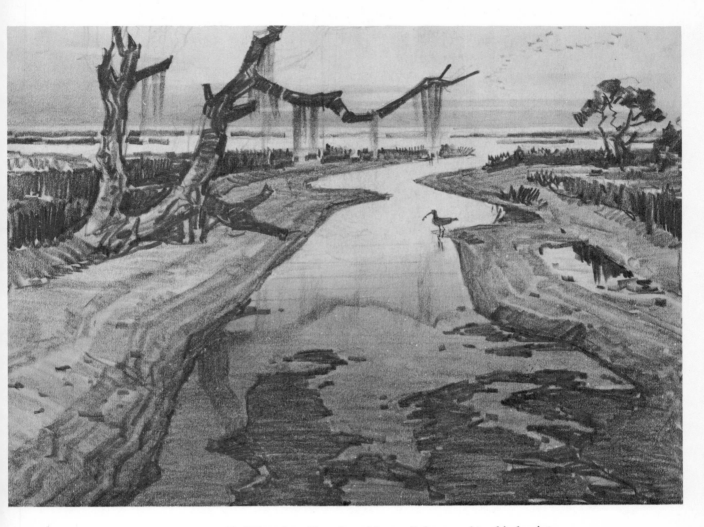

Ted Kautzky Drawing with pencil sharpened to chisel point.

Pencil Points

A masterpiece can be made with a single pencil (of any variety) and a sheet of paper, but many artists prefer to carry several or even a battery of various kinds and points. The needle point of a freshly sharpened pencil is excellent for some work—as a delicate outline or sharp and precise bits of detail—but a point that is partly worn down is possibly an even better tool for most work. Sharpening the lead to a chisel-like edge gives you the advantage of a broad stroke, most useful in laying in larger areas of tone or texture. So three pencils—each with its different drawing point—give you rapid versatility of stroke. To these may be added, if desired, other pencils with harder or softer points.

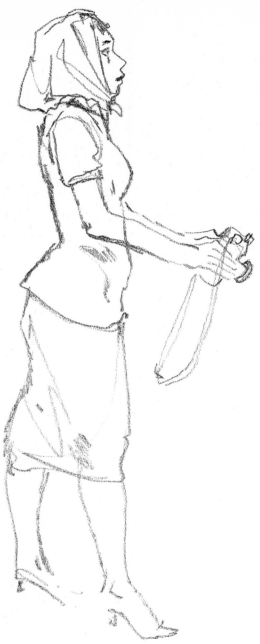

Producing Tonal Effects

Some artists like the tones produced by rubbing with their finger or a paper stomp. And a kneaded eraser is a virtually indispensable tool. Soft and pliable, the eraser can be manipulated by the fingers into many desired shapes. It will not only erase unwanted lines or tones, but squeezed into a point, the eraser will remove pencil tones

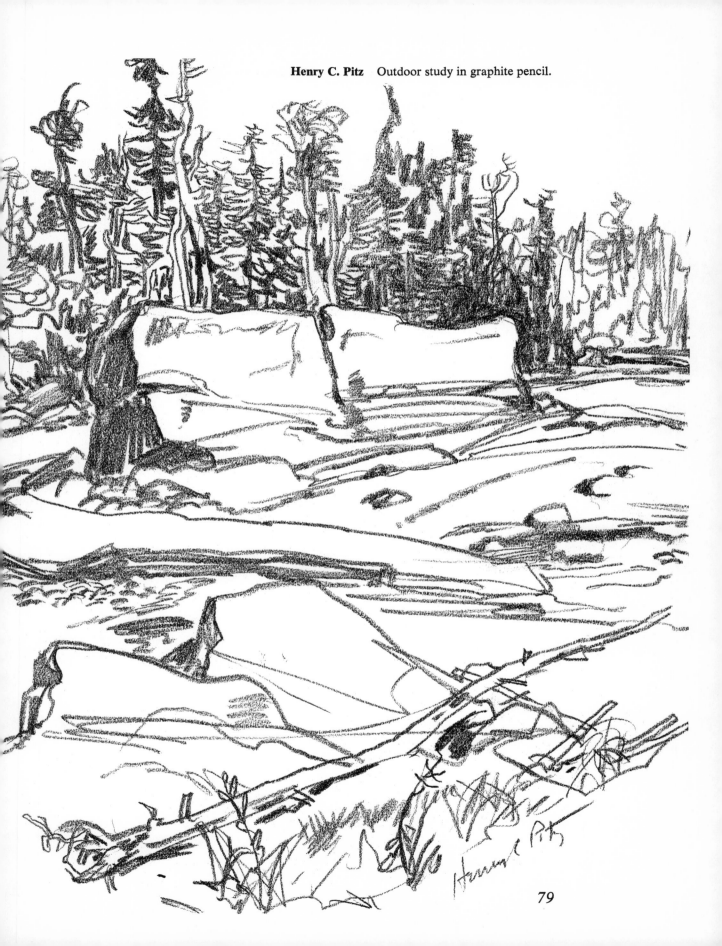

Henry C. Pitz Outdoor study in graphite pencil.

79

to create highlights or light traceries. If handled with considerable care, pencil drawings will not rub, but it is safer to spray them with the finest grade of fixatif. The drawing should be horizontal—or nearly so—while being sprayed, and a light coat applied first and allowed to dry for a few seconds before applying a second or third coat.

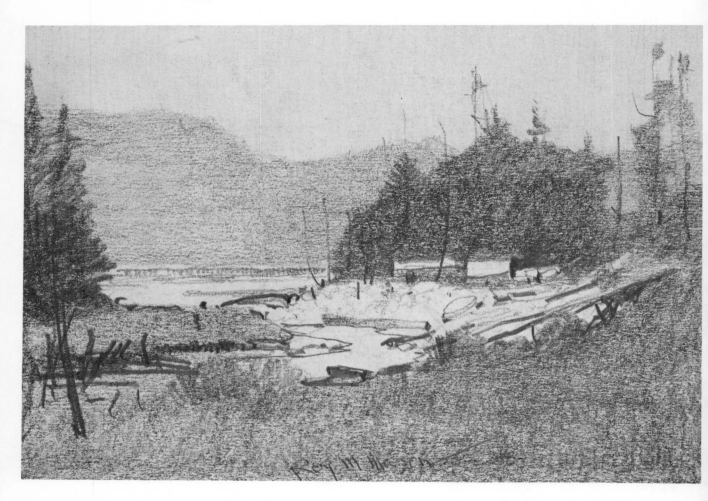

Roy M. Mason A tonal sketch in graphite pencil blocking in a landscape in simple tones.

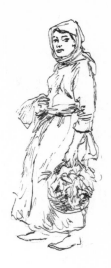

XI. Pen and Ink

Drawing in pen and ink is scarcely popular. Many who have never tried it exaggerate its difficulties. The fact that the ink line is so definite, difficult to change or erase, frightens others. The firm definition of the ink line and its resistance to change or erasure are virtues instead of faults. I recommend the medium for those who are too tentative, overly vacillating, and evasive about making firm pictorial decisions.

The ink techniques do not encourage a hazy, undecided approach. The ink line is a firm statement, a commitment, not easily modified. You are encouraged to observe and think before drawing. Fumbling and faking are clearly visible. It is a very poor medium for concealing errors. For these reasons, it is excellent for anyone working toward clarity and positive statements. Your first experiences with the ink line may discourage you, but perseverance will gradually generate your confidence. It is an excellent idea to practice its forthrightness alternately with a more malleable, easily changed medium such as charcoal.

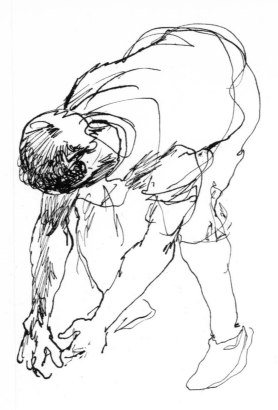

Henry C. Pitz Sketch with crowquill pen.

Pen Points

Materials for pen and ink are few, simple, and inexpensive: a pen point and holder, a bottle of ink and a sheet of paper. There is a wide choice of kinds and sizes of pen points and you should try several kinds, for the type you select has considerable bearing on the effect you obtain. You may use ordinary pen points, but they are usually less responsive than the artist's points made by Gillot, Hunt, Esterbrook, Mitchell and others. The most delicate point is the *crowquill,* a wonderfully responsive pen but often leading to fussiness in the hands of the inexperienced. Sturdier pens more suitable for average work are: Gillot's 303, 404, 170, 290, 291; Esterbrook's 356, 357, 358; and Hunt's 22. An unusually versatile pen is Mitchell's Painter Pen.

Fountain Pens

Fountain pens are the most convenient for outdoor sketching. There are several makes of artist's fountain pens, designed to use the heavy, carbon saturated India inks. The artist often encounters the problem of clogging when he uses India inks. The ordinary fountain pen does very well with writing ink, preferably black or sepia.

Henry C. Pitz White Bear Lake, Minnesota. India ink sketch with blots carefully controlled for dark accents.

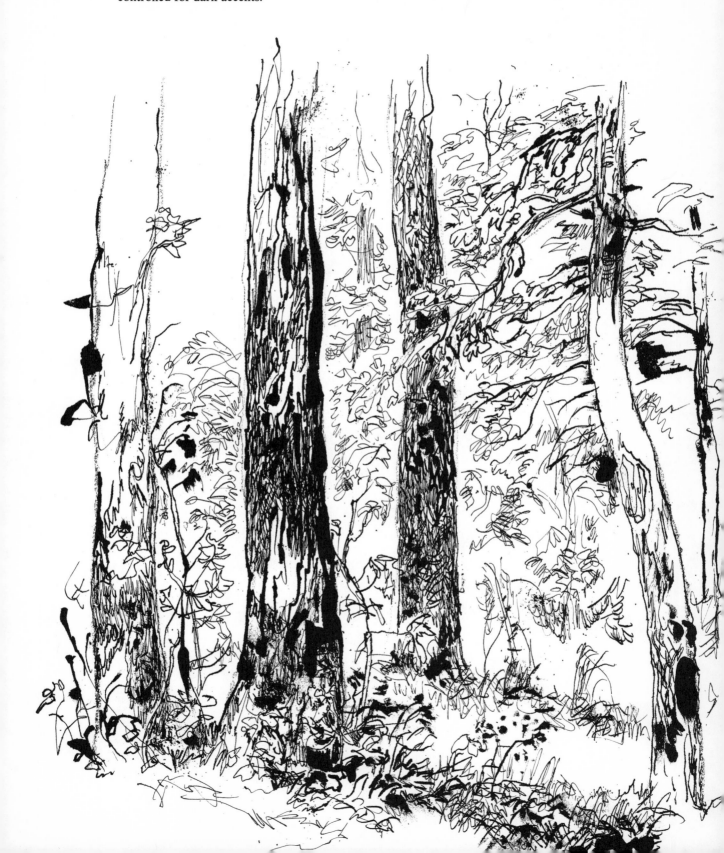

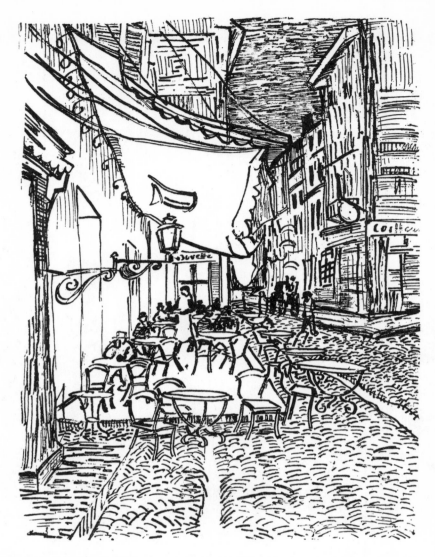

Vincent Van Gogh The artist exploited the tendency of the pen nib to split and produce a double line.

This ink is not waterproof as are most India inks, but it has the advantage of being smudged and modeled with a damp finger after drying. Ball point pens make a uniform line that is often unappealing to the artist.

Paper

You can use a pen on any paper which contains enough size to prevent the ink line from blurring. There are many varieties of bond paper which are suitable and inexpensive—the type of paper found in many sketchbooks. Choose artist papers, smooth, medium,

and rough for the effect desired. Smooth can give a fine copperplate line; medium has enough texture to give a slightly irregular and characterful line; rough induces a broken, staccato line. Illustration board and bristol board have the advantage of stiffness but are expensive.

Henry C. Pitz Olympia. Fountain pen sketch smudged with finger.

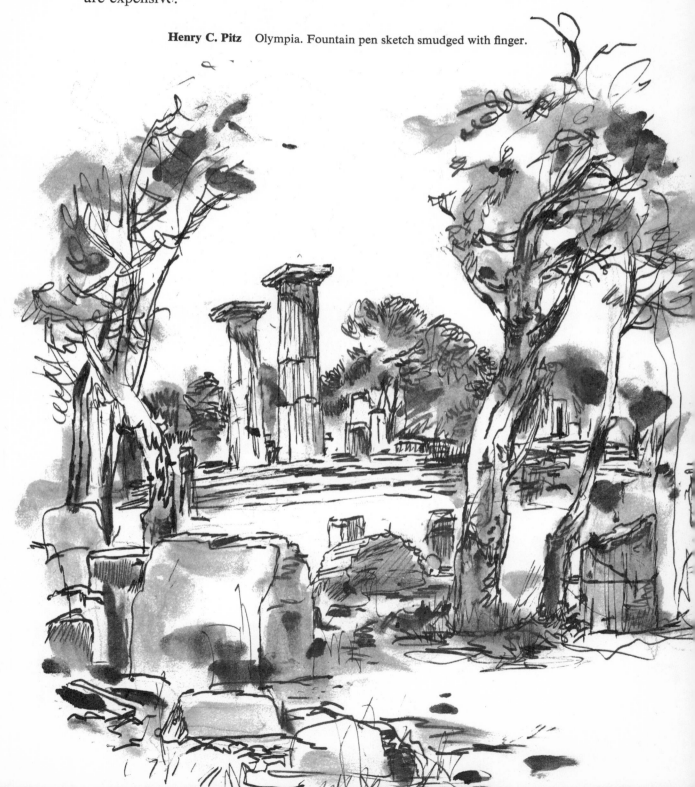

Subjects for Pen and Ink

Like all other media, the ink line is more suited to some outdoor
subjects than others. Solid forms and firm edges are rendered best
by an ink line—buildings, tree branches, and rocks, for example.
It can delineate subtle modeling and blended tones (usually by
suggestion) but only by an accomplished hand. Drawing a softly
modeled cloud would be difficult in ink line, but the tracery of a
wrought-iron gate would be a sparkling subject for the pen.

Henry C. Pitz Sketch made with India ink fountain pen.

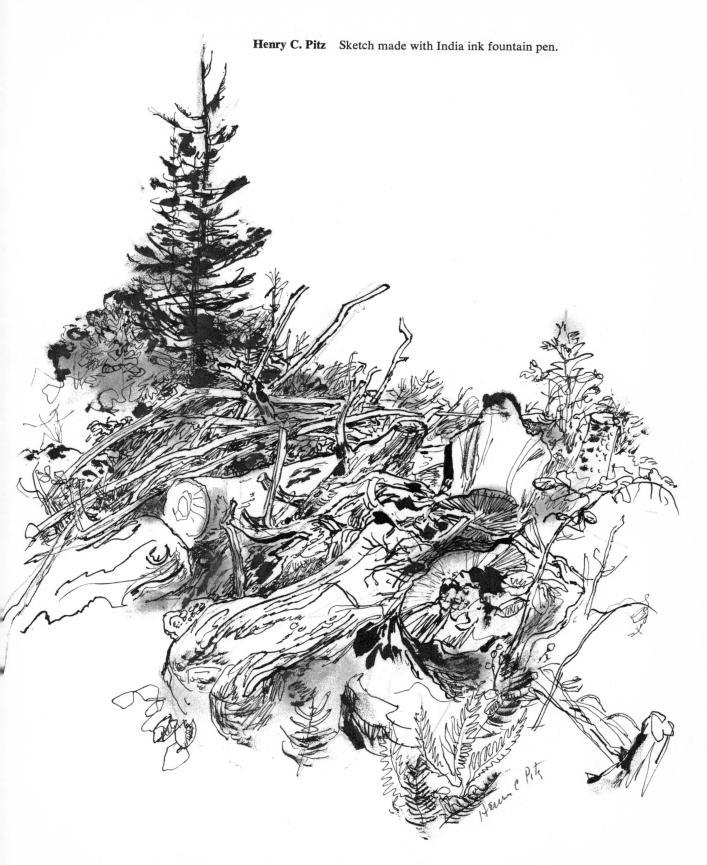

Before you set out to sketch the world in ink, it would be well to indulge in a little practice session to learn some of the characteristics of the medium. Cover scraps of various kinds of paper with all kinds of pen marks. Study the differences produced by each kind of pen and by each paper surface. It is important to get the *feel* of this tool. Its stroke repertoire is not as wide as that of the red sable brush; it will not return upon itself without tripping and sputtering. Beginners are often tempted to utilize the easiest stroke of all, from upper right down to lower left (for right-handed artists). The pen is capable of more than this stroke and should be encouraged to express its limits.

Success in ink delineation lies largely in your ability to eliminate subtle halftones and to concentrate on the sharper differences in value. Whereas a tonal medium, such as charcoal, may employ every subtle gray between white and black, the pen artist wisely limits himself to four, five, or six values.

When dark tones, other than deep black, are wanted, the usual method is cross-hatching—running one series of lines over another. You must be careful that the underlying series is dry before you add a second or third series, or blotting will probably result. Added to the normal pen line are interesting effects produced by such methods as smudging with a finger, printing textures from inked surfaces such as your thumb, rough cloth, or lace; using inked match-sticks or splinters of soft wood. In addition, are the special characteristic lines made by unusual pens like the reed pen, the goose quill, and the bamboo point.

XII. Brush and Ink

The brush with ink is a more versatile tool than the pen, but more difficult to control. With a number 3 or 4 red-sable brush (and red-sables are the best and most sensitive brushes), you can lay down a mere whisper of a line and, in the same stroke, fatten out the line into a black ribbon. Loops and return strokes are possible without the scratch and sputter of the steel nib. First, make experimental drawings using all kinds of brush lines and tones, to gain some sense of the capabilities of the brush. The amount of ink in the brush as well as the texture of the paper play an important part in the character of the brush stroke.

Dry-Brush Line

The inked brush is capable of producing two special and interesting effects: the *dry-brush* line or tone, and the *split-brush* or *multiple* line. To create a dry-brush line or tone, first wipe most of

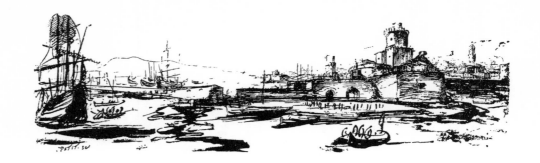

Claude Lorraine Drawing in brush, quill, and ink.

the ink from the brush on a bit of paper or blotter. In wiping from heel to brush-tip, spread out the hairs of the brush fan-wise. With the fanned out brush, still containing some ink, draw across a textured paper. A deposit of ink will be left in tiny, irregular speckles on the high spots of the paper texture. Test various kinds of textured papers. Smooth paper will not give the best results with the dry-brush line. Too much ink will not yield a dry-brush effect. The darker tones should be built up by dry-brush stroke upon stroke, often in different directions. Each time the brush is charged with ink and wiped, the tryout paper should be the same as the paper you are using for the drawing so as to gauge exactly the quality of the stroke. Dry-brush can render a whole gamut of gray tones and, of course, combines beautifully with pen and other brush lines.

Split-Brush Line

The split-brush is also arranged by splaying out the wet brush. With a needle or knife blade, you can arrange the fanned out hairs

Wallace Morgan Study in brush and ink.

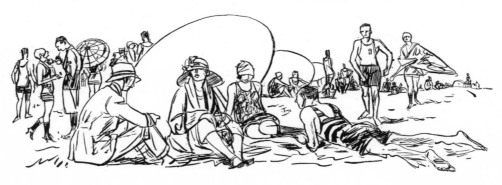

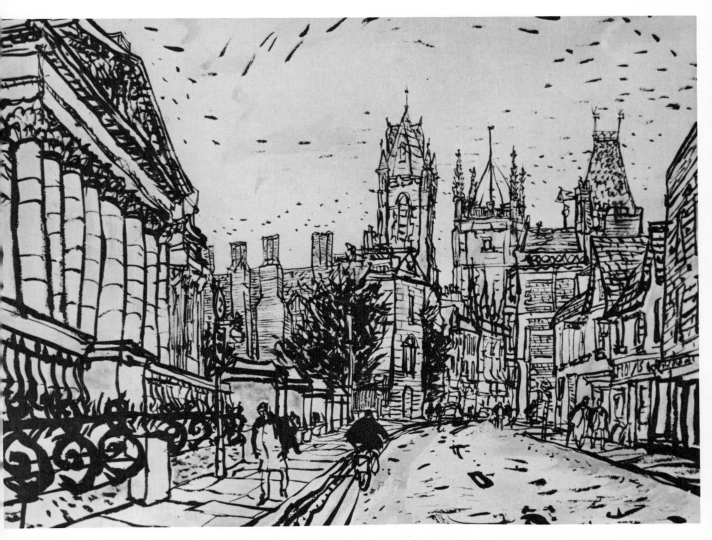

Ben Eisenstat Cambridge. Study in black ink with ochre.

in small or larger clumps. Each clump will make a mark and when you move the wet brush across the page it leaves a group of parallel lines. These clumps can be arranged to produce thick or thin strokes or to have either regular or irregular distances between them. You can rapidly build up tones of cross-hatched lines in this way. For both dry-brush and split-brush techniques, old brushes that have worn down tips are very suitable.

Brush Techniques

The brush line, like the pen line, is best suited for sharp edges and solid forms. But the use of dry-brush technique permits a more effective way of blending tones than does the cross-hatching of the pen point so the brush, properly controlled, can yield a larger variety of tones.

Both techniques—dry-brush and split-brush—have to be worked with to extract the most from them. Because of the chores of dealing with open ink bottles and preparing the brush, these techniques are little suited to the instantaneous type of sketch. Where there is reasonable time, however, elbow room and freedom from other distractions, the techniques are splendid for rendering fabrics, architecture, and green growing things.

Henry C. Pitz Brush drawing of horse.

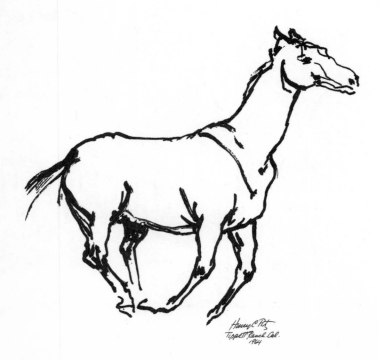

XIII. The Felt Tip Pen

The felt tip pen is a newcomer to the artist's tool kit, but it has made a place for itself because of its convenience as a sketching instrument. The felt tip pen can be whipped from the pocket and put into use in a few seconds. It is light, not bulky, will not spill, and should not leak.

Selecting the Felt Tip Pen

There are a number of types of felt tip pens. The dip type has to be dipped into ink, like the ordinary pen, so it is not often used for outdoor sketching. There are two variations of the reservoir type: in one the reservoir is sealed in and when the supply is exhausted the pen is thrown away; the other type has a reservoir which is refillable by means of a glass dropper. The wick type nibs are usually of felt or nylon and come in various shapes: the tapered point, square, wedge, and T-shapes. Except for the pointed nibs, the other points are capable of making various kinds of marks by using corners, edges, and flat sweeps.

Two types of ink are supplied: oil and water based. Both kinds of ink are penetrating, especially the oil based, which can penetrate completely through a thin sheet of paper on to an under sheet. There is no assurance that this ink is permanent and some of the oil based inks exhibit corrosive action upon the drawing paper. Recently, there have been claims that oil based ink has improved. The water based inks are less penetrating and less fugitive.

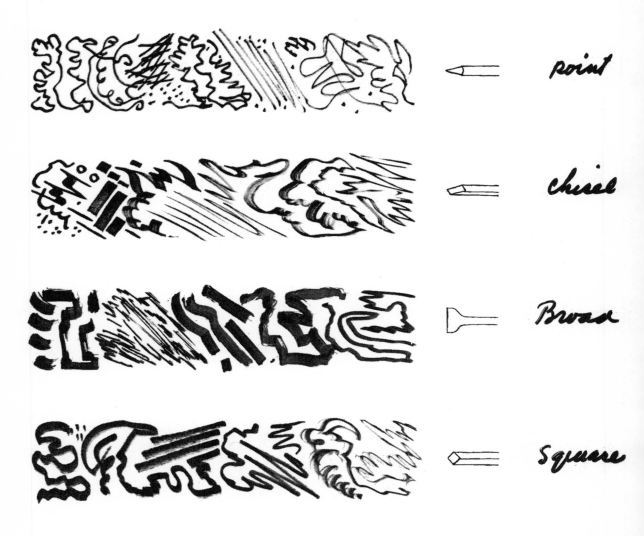

Tips Most felt and nylon tip pens are pointed but other tips are available in some makes and they enlarge the repertoire of strokes.

All in all, the felt tip pen, in spite of its limitations, is probably the most satisfactory for quick sketching. Like pencils and crayons, it is available in a few seconds and can be carried about without the slightest inconvenience.

The felt tip pen is scarcely a pen, nor yet a brush, but no satisfactory name is available for it. The point will give a line of equal width and with pressure will expand a little, but not to the extent

Henry C. Pitz Drawn with broad chisel-shaped felt tip.

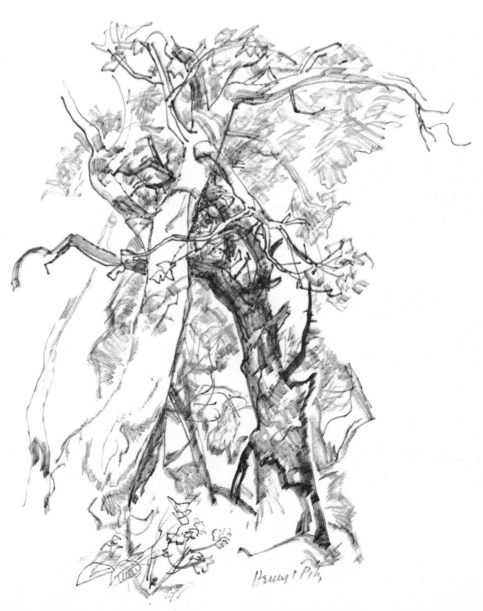

of a flexible steel nib, and in no way approaching the thin and thick potential of the brush. But after you experiment you will find that it can produce characteristic marks of its own.

The inks dry instantly. The oil based inks resist water and smudging, but the water based inks are water soluble. This however permits modeling with a dampened finger which many consider a great advantage. All these pens should be kept tightly capped when not in use or the inks will dry out and harden. If this happens,

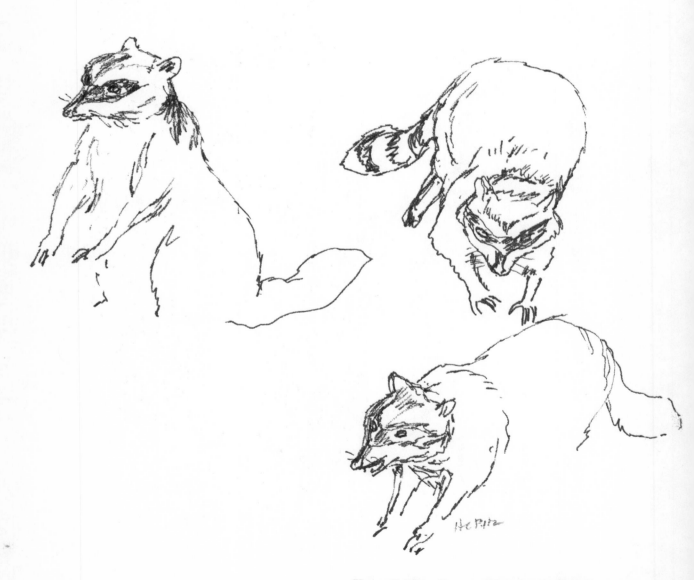

Henry C. Pitz Drawn with pointed nylon tip pen.

the oil based nib can be soaked in a special solvent sold by the manufacturers, which usually restores the pen to usefulness. The water based nibs respond to soaking in warm water. The pens with felt nibs permit an interchange of the various shapes of nibs; in fact, you can trim the felt with a razor blade to suit your wishes.

When using the sealed in reservoir type of felt tip pen, you cannot regulate the ink-flow but you can control the darkness of line to a considerable degree by the amount of pressure you use. In the type

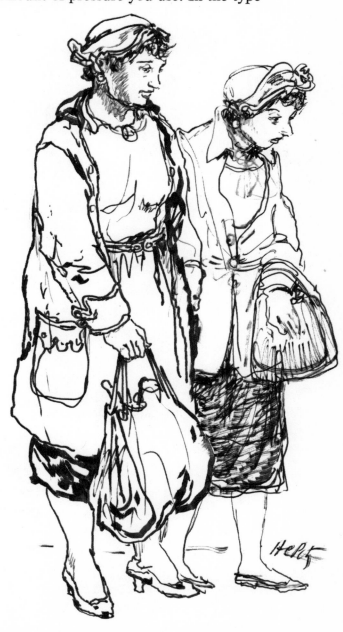

Henry C. Pitz Felt tip study on smooth tracing paper.

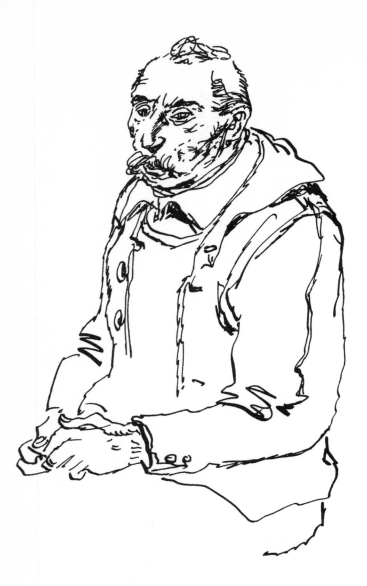

Henry C. Pitz Greek peasant.

of pen provided with valves that release ink from the reservoir, you can regulate the quantity of ink but not instantly. When pressure on the nib opens the valve and ink flows into the nib, the line produced is black and solid. This is quite satisfactory for some problems but most artists prefer to vary this with a softer, grayer line, which is produced when the nib is partly exhausted of ink. Although the nib can be partly dried by wiping it repeatedly with a rag or working it out on scraps of paper, carrying two pens is more convenient: one pen with a loaded nib and one pen with the nib partly dry.

This combination is excellent for almost any outdoor subject you may choose. The felt nib will not produce the extreme delicacy of a crowquill point or a fine red-sable brush, but its lines and tones can have a virile and calligraphic character all their own.

XIV. Charcoal

Charcoal is one of the artist's ancient media. It was popular with many of the masters, yet today is very much neglected. It is difficult to reason why, for in addition to having an appealing character all its own, charcoal is probably the most pliable of all media. It responds to the slightest touch, and can be changed back and forth with great ease, which makes it a splendid student's medium.

Using Charcoal Outdoors

I highly recommend charcoal as an outdoor sketching medium. Its ease of handling makes it an excellent medium for experimentation, but at the same time charcoal lends itself to the most careful study and finished rendering. Charcoal is very much an all-around medium for the outdoor sketcher. It is rapid, pliable, and can range from delicate to bold, from tender to dramatic in handling. Charcoal is versatile enough to render any subject, any mood, any effect of light.

Because it can be changed at the slightest touch, care has to be exercised to prevent accidental marring. It is better if the hand can

work from the shoulder without intermediate support, but some-times in placing a firm but delicate accent you will need a steadying anchor of some sort. Sometimes you can brace an extended little finger on an unimportant spot in the drawing, but more often you can use a ruler or mahl-stick resting outside the drawing to rest your arm.

After sketching in a subject, some artists work from the left top down and across to avoid rubbing. It is better to carry a spray-can of fixatif with you, rather than running the risk of transporting an unfixed drawing.

Charcoal Papers

There are quite a number of charcoal papers made especially for the medium, but other papers may be used as well. Smooth papers are rarely satisfactory, because at least a slight tooth in the paper's surface is necessary for telling lines and rich darks. Charcoal paper is not made in stiff weights, so a light drawing board (a small section of builder's board) is necessary. Moreover, you will find that the touch of the charcoal stick is more sensitive if the drawing sheet is backed up by several other sheets.

Hard and Soft Charcoal

The two commonest kinds of charcoal are hard and soft (vine). The soft or vine variety is the best all-around instrument, for it makes an easy line and a rapid tone. The sticks are quite fragile and the artist finds himself working with broken lengths of various sizes. Because it is impossible to maintain a point for more than a stroke or two, the hard variety is better for the cleancut lines and details. Both varieties blend easily under the gentle rubbing of the finger or paper stomp. With reasonable skill, charcoal tones can be manipulated back and forth for a long time without losing their fresh look but the rubbing must not roughen the paper's surface and the fingers and stomp must always be dry. A perspiring finger can quickly ruin a handsome passage.

Kneaded Eraser

You will find that a kneaded eraser is a necessity. Pressed into suitable shapes by the fingers, the eraser can deftly lift out high-

Edward Hopper Charcoal drawing. *Philadelphia Museum of Art Collection.*

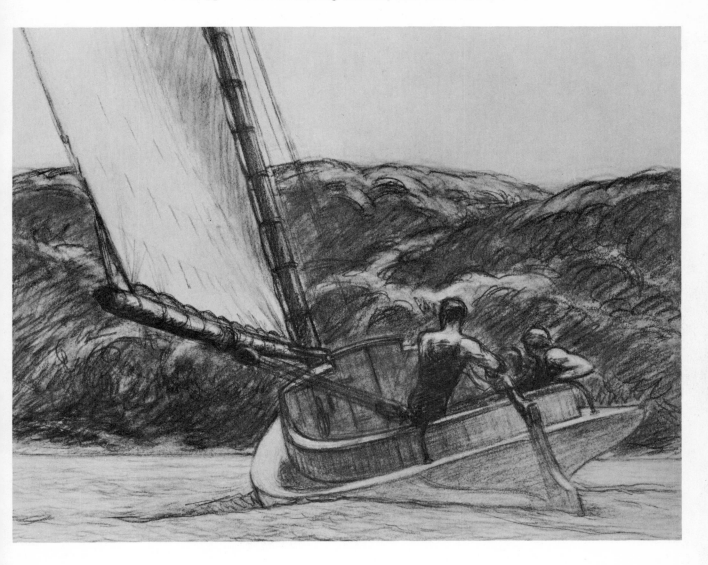

lights and light passages. As the eraser accumulates a coating of charcoal, you must knead it to present a fresh clean surface.

Compressed Charcoal

Two other kinds of charcoal are in common use: compressed charcoal and charcoal pencils. Compressed charcoal is a manufactured charcoal in round thickish sticks that give a velvety intense black. Used by itself, the stick is excellent for large, loose sketches, dramatic in black-and-white contrasts. It rubs out easily under the fingers, blending smoothly and darkly. Because of the slight oiliness

Henry C. Pitz Soft charcoal drawing.

in its texture, compressed charcoal is at its best when handled freshly and straightforwardly. Repeated rubbing and manipulation cause the strokes and tonal surfaces to deteriorate and grow unresponsive to further modeling. Although compressed charcoal can be combined with the other types of charcoal for the sake of its intense blacks, you must not fuss with it or unpleasant passages will develop and the differences between the two types of charcoal will assert themselves.

Charcoal Pencils

Charcoal pencils are what the name suggests: rods of charcoal encased in a wood shaft. They have the advantage of being cleaner to work with and do not crumble and break as natural charcoal does. Pencils work well with the stick charcoals but cannot be used for the same broadside treatment. They are useful for detail and finishing touches and if you have room in your pockets for only a

minimum of materials, pencils are the kind for casual handling and easy transportation.

Charcoal, even in pencil form, is scarcely the most suitable medium for the pocket-sized sketchbook. Charcoal does not require very large surfaces, but it is at its best when given reasonable space to maneuver. It combines well with other media.

Appraising Your Sketch

There is one drill in which you can exercise charcoal's special qualities. After certain periods of sketching there are interludes of appraisal, in which sketches should be compared and judgments passed. Perhaps you will ask friends and others to express their opinions. There are certain to be some drawings, perhaps many, which seem unfulfilled. There may be different solutions to improving them. An excellent and rapid way to experiment with possible changes is not to touch the original but to fasten a sheet of tracing paper over it and copy lightly the principal forms of the original. A whole series of changes—alteration of tones, shifting of compositional elements, corrections of inadequate drawing—can be quickly carried out on a succession of overlays in charcoal. You can then place the experimental overlay beside the original and make comparisons. This can be one of the most rewarding lessons.

XV. Pastel

Pastel immediately suggests color to most of us, a rainbow of soft, high-keyed hues. But since full color is beyond the scope of this book, we have to consider this delightful medium in its monochromatic or near-monochromatic aspects. This brings pastel close to charcoal: its handling and its effects are similar.

Pastel, for the outdoor sketcher, is largely a medium for broad effects. It is ideal for rapidly changing cloud forms, fleeting shifts of light, and soft, melting distances. Pastel is a good medium for those inclined to over-elaboration.

Selecting the Color

Black pastel, with a number of gradated grays and white, are the usual monochromatic colors. But blacks and grays vary and we should be aware of certain subtleties. Blacks and grays can be either cool or warm in color. We may want to take advantage of the properties of both and use them together, but if only one range is used, most artists prefer the mellowness of the warm range. In

addition, sepia, burnt and raw umber, and other dark browns are favorite colors which may be used separately or in conjunction with each other and with black and gray. White pastel is an essential for restoring lights or for modifying the darker colors. White plays an important part when sketches are made on tinted papers. Pleasantly toned papers in a muted color range are suitable for most subject matter, but special occasions might call for very dark or aggressively colored stock.

Papers for Pastel

In general, the papers suitable for charcoal are equally good for pastel, but there are certain specially prepared papers and boards for pastel rendering. These usually have a special toothed surface —like a fine grade of sandpaper—and some artists may prefer them, but they are expensive compared to average grades of drawing paper. Paper is such an important factor in sketching that most artists like to seek out and collect all promising kinds for future experimentation. Even the ordinary papers of every day use, like wrapping paper, often have inviting qualities.

Hard and Soft Pastel

Pastels are usually found in two grades—hard and soft—although sometimes intermediate grades are made. The soft varieties are splendid for large sweeping masses of tone but they have to be used with a sensitive hand, for they crumble easily and since they are of little use for definition or detail, they do not hold a point. The hard pastels supply this last need, but even they will not give the fine, clean edge of a pencil.

Water Soluble Pastel

In recent years, several new types of pastel have been produced. One is a fairly hard stick that is water soluble, which you can use in the same way as ordinary pastel, or to produce effects similar to watercolor. The sticks may be dipped in water and when drawn across a surface, the lines spread and blend a little. Or you can draw a picture in the ordinary way and then, with the drawing lying flat, you can stroke a brush, loaded with clean water, over all or portions of the picture. The water tends to dissolve the pastel and it diffuses and blends the line. Still another way is to sketch

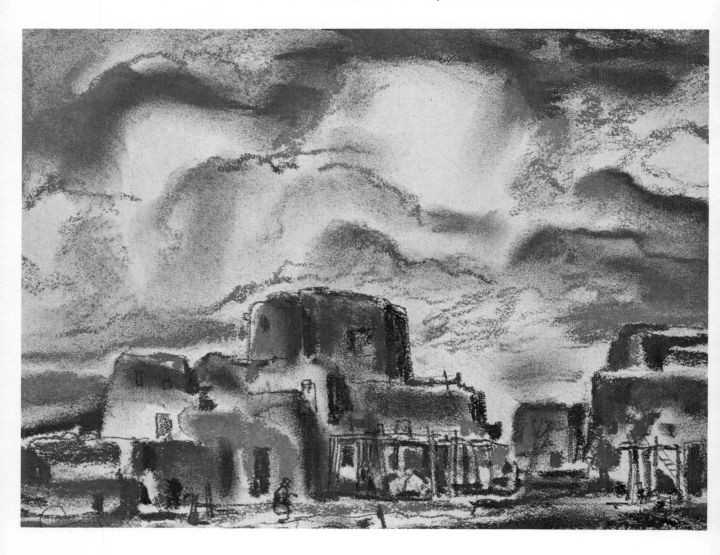

on the surface already dampened with brush or sponge with the drawing in a horizontal position. The amount of water on the drawing surface, varying from slightly moist to flooded, offers opportunities for a variety of effects.

Oil-Pastel

Another new variety is an oil-pastel. This is somewhat less malleable than ordinary pastel and has a heavier look because of its oil content. By using turpentine instead of water, oil-pastel can be

Henry C. Pitz Study of rocks and trees.

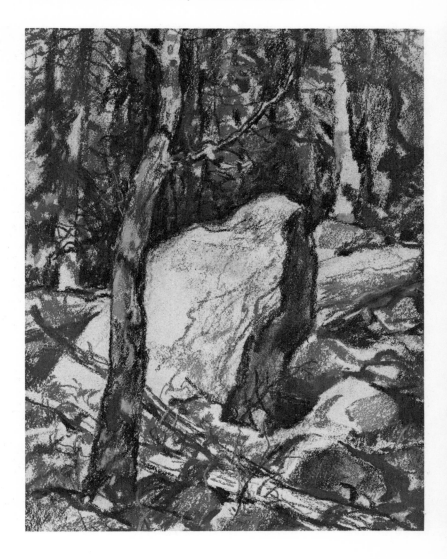

dissolved and handled in much the same way as the water soluble pastel. Some painters in oil are now using oil-pastels for retouching over dried layers of paint. When sprayed with retouching varnish, it unifies with the paint.

Pastel Techniques

One of the delights of pastel is the way it blends and spreads under the touch of a sensitive finger. This is so easy and such a pleasure that the artist is sometimes coaxed into softening every mass and

blending every edge, producing a uniformly innocuous result. The stiffening influence of a clean edge or a definitive line is usually needed to counteract the blandness of smoothly modeled tone.

Differing qualities of texture are also an advantage of pastel. You can create a completely burnished and smooth tone as well as a light touch that only leaves its mark on the high spots of the paper surface giving a broken, speckled line or tone. Some pastel artists prefer to work over and rub in the drawing, piling one passage upon another until the deposit of pastel is heavy and every inch of paper is covered. Others prefer to draw as sparingly and directly as possible, leaving areas of clean paper as eloquent intervals. Both approaches have their advantages and limitations. You should try both.

Pastel is one of the most permanent media if you protect it from rubbing. Pastels should be sprayed with a high grade fixatif—usually called *pastel fixatif*—which should darken the tones only slightly. When framed, pastel drawings are placed behind glass.

Henry C. Pitz Pastel study in earth colors and black.

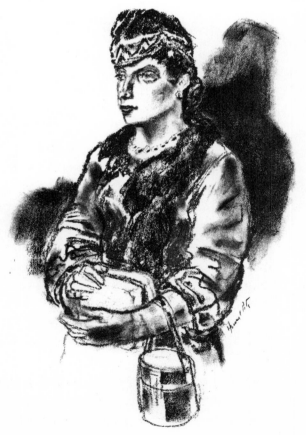

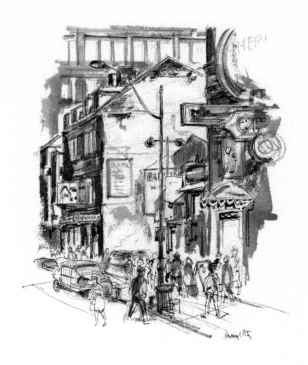

XVI. Wash

Watercolor, in some form or other, is one of the most ancient media. It is considered a difficult medium by some and it is true that expert control is not easy, but the same could be said of any medium. Its actual application is simple: a moistened brush is rubbed on a cake or dab of pigment and then the charged brush is drawn across a sheet of paper.

Watercolor Paper

The transparent type of watercolor is probably the most used for wash drawing, for the transparent wash is one of the great charms of watercolor, unobtainable in any other medium. The sparkle and buoyancy of the transparent wash is produced by the reflected light striking the white paper through a thin film of color. This means that the paper is of great importance. For maximum sparkle, a

Henry C. Pitz Brush drawing of a leaping deer. A few areas of wet brush but mostly dry-brush technique.

white paper is necessary, as well as a certain amount of tooth or texture. The paper should also possess the right degree of absorbtion for an effective wash.

A few ordinary papers meet these requirements fairly well, but most artists use the brands made specially for the watercolorist. The best are the imported hand-made types, expensive but giving maximum satisfaction.

There are also less expensive, machine-made sheets that are serviceable and are particularly indicated for beginning and practice work. Some bond papers and illustration boards give excellent results, but remember that thin, lightweight papers will curl and wrinkle under a watercolor wash. These papers can always be mounted on stiff cardboard or dampened and fastened down along their edges to a drawing board with masking tape.

Watercolor Brushes

The only type of brush that gives full satisfaction is the red-sable. Numbers 3, 4, and 5 are good all around sizes. They will make a hairline and, with a little more pressure, will expand to a wide ribbon of wash. Larger sizes are valuable for those who work on a large scale and the flat 1, 1½ and 2 inch red-sables are splendid for big, rapid washes. There are also a large variety of Japanese brushes available and they are preferred by some artists.

Paints

There are many good brands of watercolor. The colors most used for monochromatic work are lamp (cool) and ivory (warm) blacks, charcoal gray, sepia, Van Dyke brown, and raw sienna.

Pans of dry color are available, but most artists prefer the tubes, squeezing out enough color for each sketch. Color not used immediately need not be wasted; it will dissolve when moistened again.

Wash Techniques

Sketching in wash is pretty hopeless unless you fasten the paper to a rigid surface. It is impossible to work with an easel that holds the drawing in an upright position, because the wash runs down

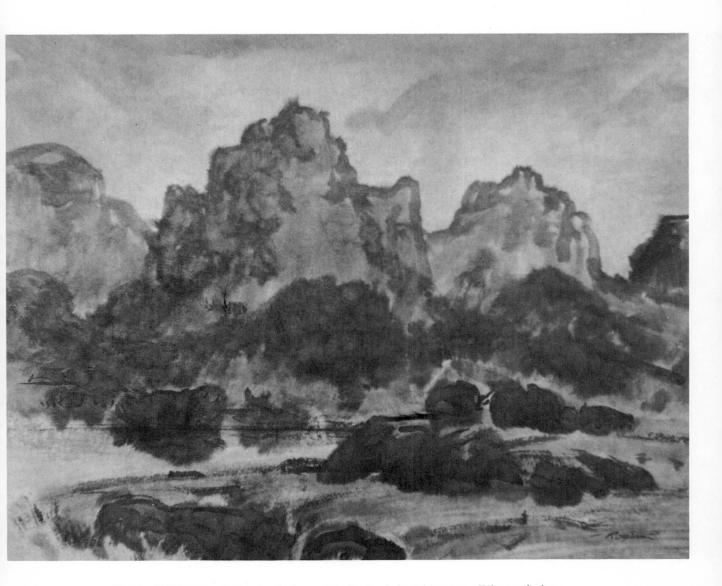

Charles B. Rogers A *Sumi* painting partly in the Oriental manner. When painting in a wash of water and stick ink on thin Japanese paper, the brushwork must be deft and unworried.

the paper. For most washes, however, a slight tilt is desirable, since the surplus wash collects at the lower edge and can be lifted by a dry brush. Some techniques call for each part to be painted in separately and allowed to dry, lest the parts fuse together. But another method is to dampen the paper entirely, or in part, and paint directly on the wet surface. This results in an interesting blended effect, particularly suitable for skies or distant masses of

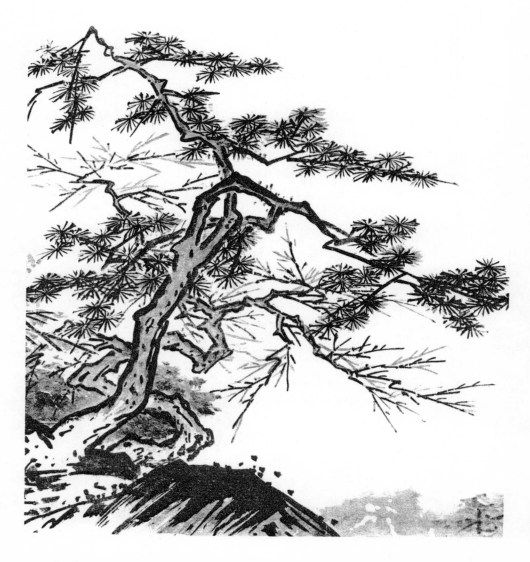

Sesshu A section from a Japanese landscape scroll of the fifteenth century. Study the Japanese method of rendering tree and foilage forms and compare them with Western methods.

hills and foliage. Sometimes the effect is allowed to dry and fresh, crisp touches are added to give firmness and definition to the sketch. When you do a wash, remember to bring a sponge for dampening the paper and clean rags or paper tissue for lifting out areas of color.

Although watercolor encourages directness, it is nevertheless possible to modify and manipulate a watercolor considerably without giving it a worried look. To do this not only requires skill, however, but a fine grade of hand-made paper for a foundation. Modifications of transparent wash can also be made by using opaque watercolor.

Opaque Paints

There are a whole array of *opaque* water soluble media: gouache, casein, acrylic, and so-called *tempera* or poster colors. These are all body colors which, when diluted with a generous amount of water, will yield near transparency to translucent washes and, when used full strength, are completely opaque. Sometimes a special painting medium or emulsion is supplied with the casein and acrylic pigments but, unless used thickly (impasto) this is not necessary; water is sufficient. These two types, once thoroughly dry, are resistant to water.

The opaque pigments work well on tinted papers and using this is a very quick way to sketch. Using a middle toned paper, you can paint in the darks, add a few lights, and striking tonal effects can emerge in a few minutes.

Equipment

Carrying watercolors into the field requires a few extra items of equipment. Besides paper, brushes, a few tubes of color, and probably a watercolor box for mixing, you will need a water container. Even where a water supply is known to be available, some receptacle is necessary. One solution is an aluminum canteen and canteen cup, obtainable in most army surplus stores. Some artists have been known to carry water in an old rubber hot-water bag.

Wash is a most versatile and expressive medium but unsuitable for crowded circumstances. As a sketching medium, it is better reserved for places that afford elbow room and quiet.

Wash has an individuality different from any other of the media discussed, and you may prefer it to any other, with good reason.

Its range is very great—subtle or forceful, crisp or elusive, loosely handled or meticulous, casual or mechanical. Its gamut of textures can also be very extensive and it combines well with all the linear media. For most people, the brush is more difficult to control than the pen, but its control is something well worth the constant practice it usually demands.

Henry C. Pitz Rocky hill. A sketch made in watercolor and ink wash.

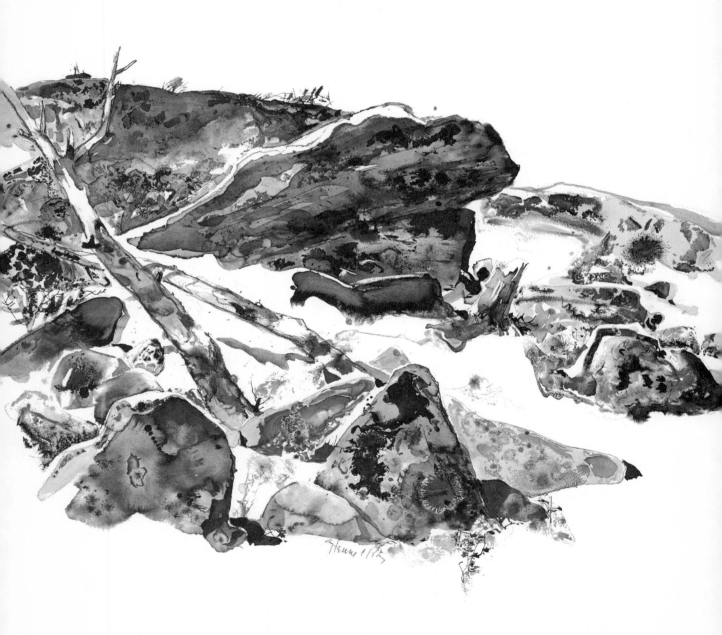

XVII. Mixed Media

There is nothing new about the mixture of two or more media, but in recent years there has been widespread technical experimentation and every conceivable combination has been tried. Many combinations are natural and effective, some are forced oddities. But there are many media that harmonize with and complement each other. These combinations offer a wider range of textures and fluidity of expression than any single medium.

Ink Line and Wash

A favorite combination is the union of line and tonal media and one of the oldest of these is the ink line with wash. Many of the world's masterpieces of draughtsmanship were executed with a quill pen dipped in bistre (brown) and fortified with light washes of the same ink or of some water soluble earth color. Today we usually use a waterproof type of India ink—black, brown, gray, or mixed to taste from several monochromatic colors. Washes of

Henry C. Pitz A sketch made with pen, brush, and ink with a few areas in light wash.

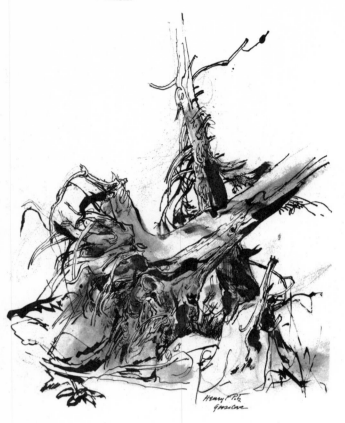

watercolor can be brushed over such a sketch without fear of rubbing or running the image. This procedure divides the multiple problems of sketching into, first, linear draughtsmanship and second, tonal and local color relationships. The watercolor washes can be deepened or lightened with a sponge without obliterating the ink lines beneath. In certain cases, some form of opaque watercolor may be added for highlights or other light colored detail.

Pencil and Wash

An equally common combination is pencil or crayon with wash. The pencil may be used unobtrusively to lightly indicate the principal forms which will be defined better by the wash values. The pencil may be used also as a bold and assertive framework of line to be supplemented by the addition of wash. The softer grades of pencil and many of the crayons will lift a little under the brush. This can be considered desirable or not according to the effect you

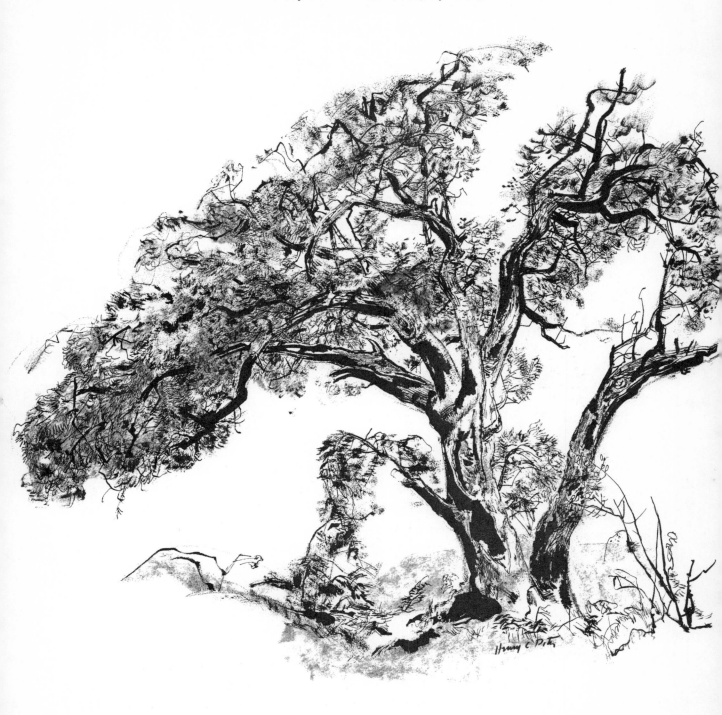

wish, but if you do not want to change the pencil line, spray the surface with fixatif before applying the wash. The many types of crayon available offer a wide variety of textures, some of them producing interesting effects when rubbed by a dry or moistened finger. The progression need not be just from pencil line to tonal wash; you may add pencil or crayon over a wash area and shift from medium to medium as the effect demands.

Ink Line and Charcoal

A combination that is little used but has great possibilities is the union of ink line with tones of charcoal. The ink line, made with pen or brush, is used to make a key drawing of essential forms. Over this clear and firm basic drawing, you can draw the charcoal tones (soft or hard), rubbed, wiped out, or blended without destroying the underlying ink drawing. This is a splendid method for experimenting with various tonal effects. The final result must be thoroughly sprayed with fixatif to prevent smudging.

Pastel and Ink Line

A combination of pastel and ink line can be used in the same way. There are enough varieties of pastel to suit every purpose and they can be applied freshly or rubbed in with finger or stomp. Some artists prefer to use the rubbed in tones of pastel as a foundation, preparing a drawing of tonal forms without precise definition. This foundation drawing is thoroughly fixed, and then calligraphic ink lines—applied with pen or brush—are drawn over the pastel tones, defining the forms and forming a linear arabesque over a tonal foundation.

Ink Line and Other Media

The ink line is used in so many combinations because of its ability to supply firm but free definition. It works sympathetically with all media except those that are oil based. Even oil based media are compatible if the ink is used first as a foundation drawing, and the oil pigment washed over it. Ink combines happily with all water soluble pigments including casein and acrylic paints. Interesting and unpredictable effects can be produced by drawing the ink line into areas of wet watercolor, gouache, acrylic, or casein pigment.

Another interesting series of effects can be created by drawing into similar wet pigment areas with a special type of water soluble pastel.

Often there is good reason for combining not merely two, but three or more media in one picture. As practice and experience develop your insight into the properties of each medium, desirable combinations will suggest themselves. There is a natural fascination in the handling of all media and in their action with or against each other. Most artists play and experiment with media for the sheer pleasure of it, but their ultimate use is only as a means to an end.

Henry C. Pitz Pencil, pen, brush and ink, and black pastel.

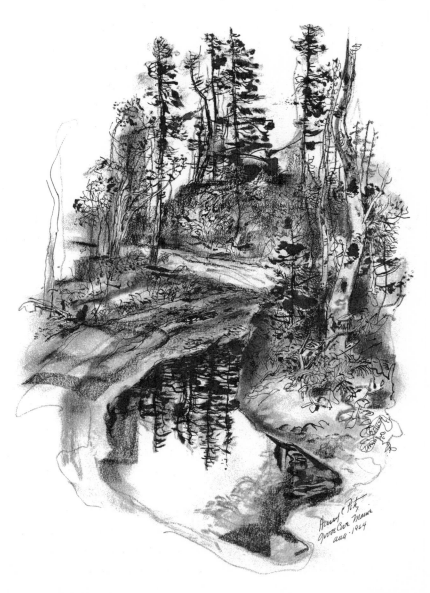

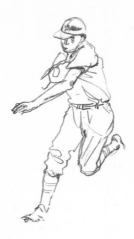

XVIII. The Visual Memory

Often the artist is inclined to think only of the immediate problem and of its immediate pictorial solution. It is natural and right to muster all your faculties to the successful solving of the problem in hand, but this intense concentration should not blind you to the fact that the sketch or finished picture is not the end of an episode, nor perhaps even the most important product of it.

Accumulating Impressions

Concentrating on a pictorial problem is an *experience* and it should, and does, leave a deposit. For some, it leaves very little but for others there is great enrichment and, perhaps, new understanding. Some of the deposit rests on the level of consciousness, some sinks to the subconscious strata where it lies in wait for a propitious moment to reveal itself. Sketching piles up an accumulation of impressions and this accumulation should become, in time, a great storehouse of images. There is no reason why this storehouse should

remain an inert repository; its wealth should be spent constantly in creative work. Use does not diminish its riches; in fact, it augments them.

Developing the Visual Memory

The mental storehouse—the visual memory—should be filled with usable material, basic ingredients for countless possible creative efforts. Not only does it grow with time and effort but even of itself. Deep down in the inner caves of the subconscious, the visual memory has a breeding life of its own, producing strange and unexpected cross-fertilizations and matings. The children of the subconscious are the artist's so-called inspirations.

Most artists are blessed with natural visual memories. Their eyes instinctively scan the life about them, their minds sort out and mull over the accumulating impressions; their imaginations play over the material and invent new combinations. All that needs to be added to this sequence is skill sufficient to give form and order to the new imaginings.

The Hungry Eye

For some, the visual memory is weak or dormant. But if desire is present there is always chance for development. It must begin with *desire,* not merely a dogged, iron resolution of the will, but a deepseated delight in scanning all the faces of nature: an eagerness to examine the kaleidoscope of the world; an absorption in sight, sound, and feeling; a craving for new shapes and colors. This is cultivation of the *hungry* eye.

The visual memory can, at times, be highly analytical, deciphering the intricate structure of things; at other times general, concerned with atmosphere, mood, and all-over appearance. But, if consciously directed at first, the cultivation must finally become a habit. And it is not likely to become a habit unless it becomes rewarding, a satisfaction, and delight.

In other words, the artist's eye should be receptive and appraising, not merely when pencil or brush is in his hand, but at most other times as well. Not only can he be gathering his harvest of materials for future pictures, but his eye can be creating its own pictures. The eye and mind make pictures before the hand is called

Henry C. Pitz The standing horse was sketched while relatively quiet, there was no problem of violent movement. The prancing horse could only be recorded in a few lines in the small sketch, the larger and more complete sketch was made from the retained image after this phase of action was a thing of the past.

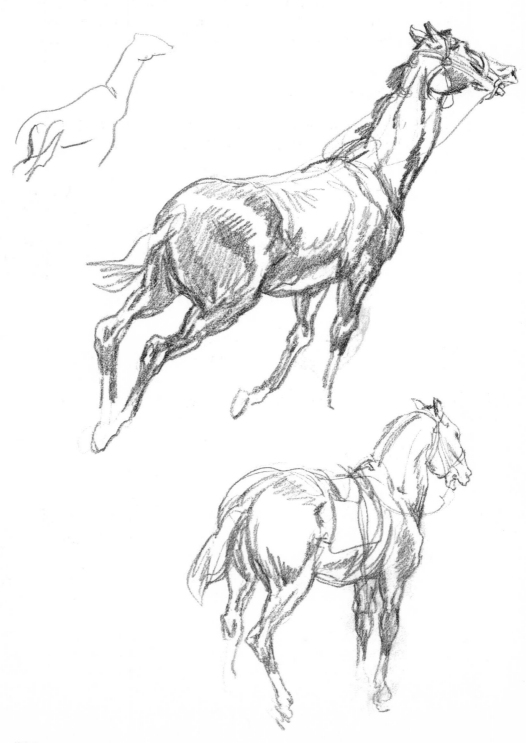

into play. The hand, important as it is, obeys the command of eye and mind.

So the education of the artist's eye and memory is imperative and is set in motion by desire. Making a conscious effort can bring rewards not only in stocking the mind with material for future pictures, but in the satisfactions of experiencing a sharpened awareness. Life becomes more interesting when it is consciously savored.

Exercising Your Memory

There are certain drills and tests which you may practice. You can, after sketching a given scene, turn the sketch under, turn your back

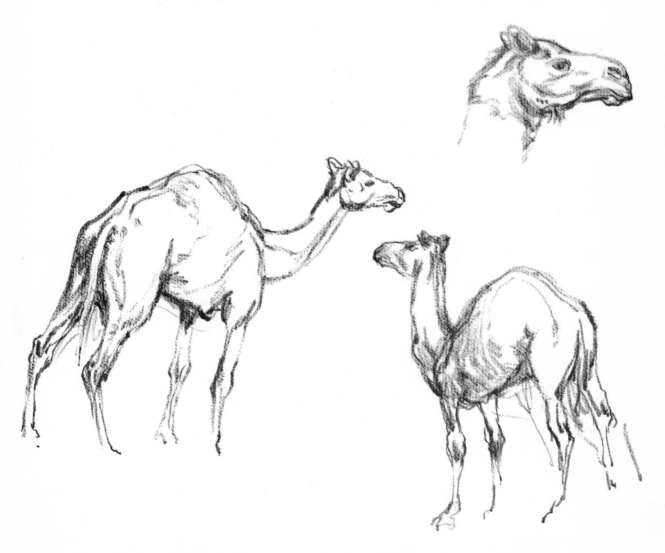

to the scene and begin a new sketch from memory. Or you may study a given scene for ten or fifteen minutes, then turn your back, or return to your studio and draw. When you make comparisons between a memory sketch and an actual scene, you must not insist upon exactitude of detail. This is well-nigh impossible. But the important things are the general character and mood, the effect of light, and the big relationships. Where there are discrepancies between sketch and subject (and there always are) you should be wisely critical. If the discrepancies or changes in the sketch enhance the power and appeal of the scene, then your creative faculties have asserted themselves and nudged your hand toward eliminating, selecting, or transforming the original material.

Henry C. Pitz These action sketches are from retained images. No artist could record more than a line or two in the split seconds these actions lasted.

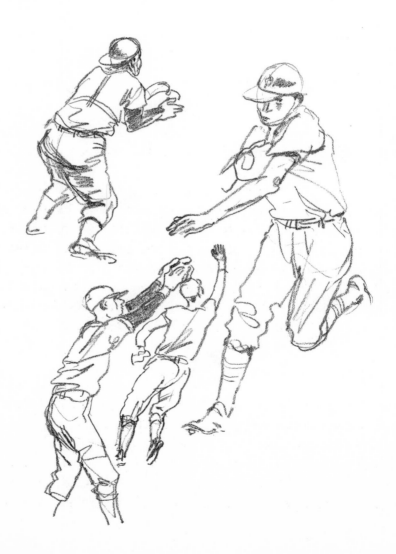

XIX. Building the Picture

Sketching can be an end in itself—its own reward. The delight and excitement of translating the seen world into line and form, creating glimpses of a new world out of the materials of an old world, is reason enough to sketch. Countless intangible blessings are by-products of sketching: the sharpened eye and stimulated awareness, the appreciation of things formerly ignored, the broadening of interests, the insight into things behind the surface.

Organizing Your Observations

The sketcher piles up observations and accumulated experience, an absorbed wealth which breeds reflection and meditation. A succession of images move out of the visual memory, sometimes clear mental pictures of things as they were seen, often strange and unplanned blends of past experiences. At this point, the desire grows to organize some of this into a picture or series of pictures.

125

Many sketches may be complete in themselves—sharp and significant statements—others will be fragments—hasty jottings and interrupted enthusiasms. But they are all tangible records and they, combined with the images of the visual memory, are a reservoir of potential creation.

The artist who has trained himself to draw only from objects may suffer a lack of confidence when he contemplates a composition in his studio. But we will assume that he has the support of one or more sketchbooks crammed with material and, in addition, the memory deposits accrued from those sketching experiences. Some, probably many, of both sketches and memories suggest greater possibilities. With a promising sketch before him he can speculate on how to enhance it.

Using Tracing Paper

A pad of tracing paper is a great help in this process. With a soft pencil, one tentative composition after another can be sketched in, each on a separate sheet. You can trace off the good portions of each sketch on a fresh sheet and perhaps supplement them with bits from the sketchbooks. A great deal of experimentation can be done this way in relatively short time. After a period of trial and error of this kind, you can trace the best composition on to a sheet of drawing paper or illustration board for rendering. The rendering can even be practiced on the tracing paper first. The tracing paper surface will not be suitable for wash, but reasonably adequate for pencil, crayon, ink, pastel, or charcoal.

Altering Your Composition

In working through a series of such experimental compositions, the opportunity opens for free transposition and invention. Instead of obediently transcribing the forms that a sliver of nature has presented, you may choose to transpose a tree here or a house there, to heighten or widen their shapes, to combine elements from a dozen sketches or invent suitable forms from your acquired knowledge. This is the kind of exercise that liberates you from the literal transcription of scenes.

This is a test, too, of how much and how vividly your memory has become stocked with forms. When you discover that your memory is inadequate, you can concentrate upon sketching the

Henry C. Pitz The step from quick sketch to a more finished picture is illustrated by these two reproductions. The gap is bridged by observation, practice, and experience. At times there may be many other intermediate stages.

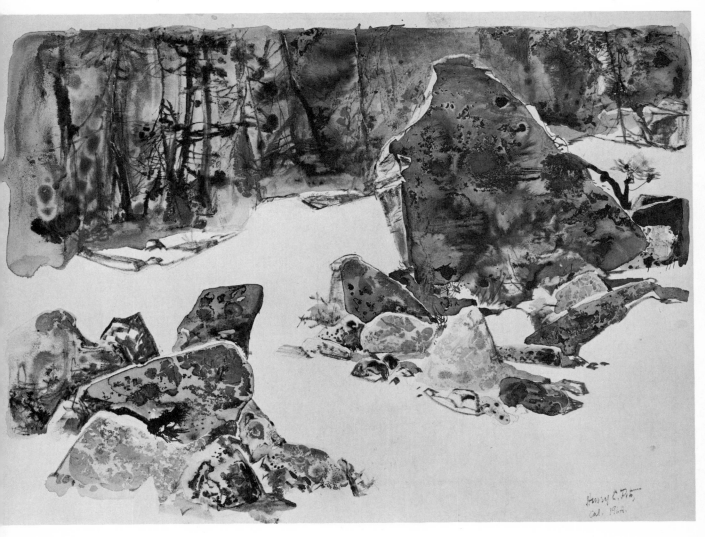

poorly remembered forms and make a special effort to imprint them in your mind's eye.

This pictorial creation, drawn from a combination of previously sketched material and remembered observations, opens the doors to great opportunities. You may choose to report the scene as literally as possible or to depart from it a little or a great deal. The possibilities are as great as your abilities.

Supporting the Vision

Combining sketches this way can often solve one of the frustrations experienced by sketchers: the all too frequent collapse of a vision as they work. It is a fairly common experience to come upon a scene with an impact of delight and wonder, to be swept by a sense of excitement and promise. Full of expectations, you set to work and draw and draw. The excitement tapers off and presently you become aware that the drawing itself contains none of the excitement, it is a dull collection of details. The reason is that you have lost the vision. The vision has faded as you become immersed in recording detail. The vision is the thing that matters—the artist's electrified insight. The minutiae of the scene is useful only insofar as it enhances and supports the vision. Never forget that a picture is a vision, not a catalog.

So it is a lesson to be learned, sometimes slowly, that the moments of vision are susceptible and perishable, but precious. Nature's great catalog of facts is always there and can always be reported in literal, pedestrian style, but the moments of vision intensify and glorify those facts. This does not mean, however, that the accurate drawing of nature's facts is to be brushed aside. Although the facts by themselves do not make a work of art, the vision, unsupported by the concreteness of natural forms is hollow and without substance.

Producing the Vision

This being so, cherish the times of intensified vision and try to hold them and transfer their qualities to paper. On the other hand, it is psychologically unwise merely to wait upon their coming. They come more readily when working grooves are established; the act of drawing tends to induce the visions. Those who draw regularly, in spite of variations in the personal inner weather, have the better

of it; the very handling of their familiar drawing tools often sets their creative spirit in motion.

Amalgamating Sketches

Getting back to the building of a picture from remembered impressions and accumulated sketches, you arrive at a promising composition using a series of tracing-paper sketches. At this point, or sometime later, you may discover a gap in your knowledge. A tree form, a certain kind of building, a cluster of rocks or some other element that is important in the composition sketch may not be in your collection of accumulated sketches nor firmly enough fixed in your memory. Back you must go to nature to observe, draw and remember. This is part of the long process of your education, to be repeated again and again. Each time you add something to your domain.

When the final composition sketch is ready it can be traced or transferred free-hand to a sheet of drawing paper or illustration board. The transfer should be done lightly and areas relatively easy to improvise should be left blank or slightly suggested. This is now the moment of decision and even experienced artists brace themselves for extra effort. They know that the artist is always on the horns of a dilemma. If he plunges ahead hoping to be carried through by the excitement of creation, he may win, but more likely he will struggle from difficulty to difficulty and lose his way. But if he is overcome by apprehension and his mind and fingers tighten with caution, the result is likely to be cramped and worried.

Mental Preparation

Perhaps this is painting a gloomy picture of the creative operation, but you must face its treacheries sooner or later. There is a middle road that some find naturally and others find only through experience. It is better to make some preparations for your final effort, a kind of mental rehearsal of the steps to be taken, or a general plan of procedure based upon the factors of your subject, medium, and abilities. Or you can prepare yourself with practice sessions with certain difficult passages. Always behind you is the comforting thought that the key composition drawing on tracing paper is available if you want to restore a lost drawing or a muddled design.

At worst, you can throw away a bungled rendering and retrace from the key drawing. This should not be a frightening thought—

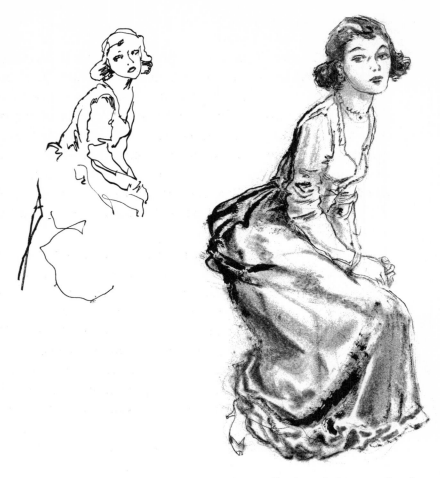

Henry C. Pitz Quick sketch to a more complete realization of the pose. Another step could be the addition of background, accessories, or other figures to the second drawing for expansion into a more ambitious composition.

the re-doing of a composition is routine for the practicing artist and is the best kind of education.

All the problems of procedure are bound up with your individual temperament. Some may find it best to attack the core of their picture immediately while they are fresh and eager, knowing that they can leave the less important elements for the time when their creative sharpness is waning. Other people may to choose to work into a picture from one of its less exacting areas, feeling the need of *warming up* to a higher level. The whole question of *warming up* is important, for not everyone can pick up his tools and be in full manual control immediately. Often the mind is alert and eager before the hand is ready to respond. The experienced artist knows the feeling of responsiveness creeping into his finger tips.

Make Your Procedure Flexible

The whole matter of picture-making goes better if it is intelligently planned. Your plans can be very flexible; in fact, your procedure better not be too rigid and confining. But allowing yourself to be commanded by every wind of influence or whim of temperament is an earmark of the pretending artist. The *committed* artist makes heavy and constant demands upon himself and is aware of the power of his will. Expecting a given amount of effort each day, week or month will not produce an automatic row of masterpieces, but the average results will be better than if left to self-indulgent chance.

An excellent test you might try is to fill a sheet of drawing paper with sketches of very familiar objects: a person, tree, chair, house, boat, or any other collection of usual objects. Such a sheet should be of deep interest. The extent of your knowledge is revealed quite plainly. All the strengths and weaknesses are easily read. This does not mean that you should expect your memory drawing to be as knowledgeable and complete as your sketches made from objects. Most artists draw with more ease and confidence from life. But memory drawing reveals how much has been retained and is available in the storehouse of your mind.

You should act upon the weak or vacant areas revealed by memory drawing. The eye can be made to study these areas more searchingly and the hand to practice them more diligently. Practice —intelligent practice—can help the weak spots and often cure them.

Creating Compositions from Memory

Finally, a well-stocked visual memory confers freedom upon the creative powers of the picture-maker. He need not be completely dependent upon the *readymade* subject on location. He can improvise or plan his own compositions, drawing upon his memory for needed material and conscious of his power to change, manipulate, and transform the elements of his composition at the dictation of his imagination. At the planning stage, this is a precious freedom. Later, as the picture develops, you may find it helpful to turn to specific things in nature for greater authenticity or you may utilize previous sketches or studies. A wider range of expression opens up to those who are both adept at delineating the confronted object, and also have available a richly stocked visual memory.

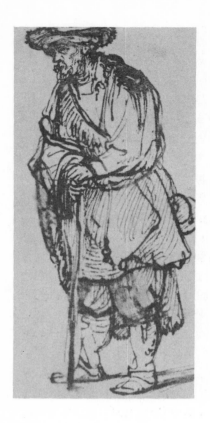

XX. The Use of Artistic Ancestors

Although the artist has artistic ancestors as well as physical ones, he does not always trouble himself to search out and understand the artists whose impulses he has inherited. Sometimes the inheritance is direct and unmistakable as when a young talent copies and admires a strong artistic personality. But often the inheritance comes slyly and unawares, by osmosis. A thousand and one little pictorial impulses can be picked up unconsciously: a way of seeing can infiltrate a personality; a manner of drawing or painting can reveal itself as a copy or development from another man's work, all unsuspected and without direct contact. Artistic genes often seem to leap from mind to mind in mysterious ways.

The growing artist should not blandly assume that he is doing it all alone. He should open his mind to what has been said and is being done, particularly since he stands at a point of time when an incredible hoard of the art of all ages has been accumulated and made readily accessible to him. He would be foolish to overlook

Rembrandt van Rijn A typical Rembrandt sketch, swift and fluent, yet searching and complete. His drawings are an endless source of instruction in the art of seeing and recording.

the opportunity that artists of past centuries would have considered a miracle.

Museums and Reproductions

Not only is more of the world's great art available in museums and public collections now than ever before, but the modern processes of printing and reproduction are turning out a never-ending flood of facsimiles and art illustrations. Original pictures are preferred, of course, but not everyone is within reach of them. However, every year more and better reproductions are available, and more libraries are adding to their art shelves. Many libraries and museums also have colored slides that can be borrowed or are used in lecture series.

The so-called "Museum Without Walls" is the modern artist's treasure and problem. He has the art of the ages to plunder for his purpose, but the very extent of it baffles assimilation. Our time may later be looked upon as an age of assimilation, in preparation for an age of creation.

There is a personal age of assimilation too, and it is usually strongest in the early years of an artist's development. This is the age of drinking in experience, preceding the reorganization and giving out. In addition to practicing the direct contact with nature, the sketcher is experiencing indirect contact with gifted minds that have practiced the same thing. What they have discovered is the present-day artist's inheritance and he would be foolish not to make the most of it.

You begin by beginning—anywhere—at the place nearest at hand. The nearest library, the closest museum; you buy or borrow a book of reproductions, attend a lecture, or enroll in a school. If you have a hunger for picture-making, one thing will certainly lead to another. You can easily find your own path.

Great names will surely be along that path: Rembrandt, Rubens, Degas, Dürer, Constable, Gainsborough, Watteau, Tiepolo, Claude Lorraine, Pieter Breugel, and many others. Some will speak more persuasively to one person than to another, but all have abundance and if this is not discerned immediately, patience and desire will usually reveal it.

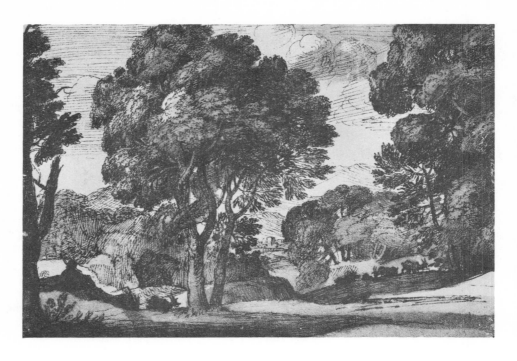

Claude Lorraine A handsome composition, born of a masterly command of natural forms.

Using Your Ancestors

The great works—the important extended compositions of the masters—are the easiest to come by, in reproduction at least. But the sketches and drawings, the less conscious and less contrived efforts, can so reveal an artist's thinking and searching. These offer the best opportunities to get close to the source.

As you draw and paint and try to solve similar problems, you begin to gain insight into these greater works. Your own successes and failures begin to breed understanding. The greater works do not exhaust readily; they continue fresh messages as your insight becomes more acute. And they are a goal toward improvement and enlargement.

Studying the Masters

The quill-pen and wash drawings of Rembrandt are an encyclopedia of instruction and inspiration in themselves. Their swiftness and power are amazing; the minimum of execution with a maximum of import reveal the extraordinary force that can be packed into a few minutes of drawing.

Force of a different kind—a vibrant sunny force—plays through the sketches of Tiepolo. Little tone is used: the skipping, seemingly casual line with a few passages of light gray shadow make the white paper dance with light. The figures written in, as it were, with a swift but knowing hand move in light and reflected light that beats back into every shadow and saturates every plane. The ease of these sketches conceals the mighty knowledge behind them.

It is a valuable experience to immerse yourself in the work of a great artist and draw strength from his strength. It is profitable too, to compare the work of the great and to observe how each creates his own world often from the same materials. Trees, rocks, skies, and land are the common materials of Claude Lorraine, John Constable, and William Turner but each has made the material obedient to his own vision.

Claude Lorraine's world is stately, mellow, and nostalgic, a memento of a vanished classical age. Ample forms, great tree masses, majestic skies, gracious gradients of land, and often ruins

John Constable Watercolor wash over pencil. *Philadelphia Museum of Art Collection.*

of a crumbled civilization are woven into calm, full bodied compositions. It is a world removed from our present condition, an Arcady which we can only experience in pictures.

Constable certainly learned something from Claude Lorraine but assimilated it to embody the less grandiose English scene. The skies are always important in the sketches of his native East Anglia. The air is moisture laden, the greenery is lush, life is slow and comfortable. These are pictures of fertility and plenty. Man's hand is on a land which he has not marred.

Turner was aware of his ancestors and he turned their lessons to his own purposes. His range was wider than either that of Claude Lorraine or Constable, a restless, untiring, prolific man. He made grandiose pictures of Roman ruins and classic landscapes, much in the Claude Lorraine manner, and other drawings of great precision and realistic detail. Some of his creations are spectacles of his imagination and others are accurate reports of places. As he developed, he discarded the details and outlined delineation and swept on to broad rushing summaries of wind, weather, and light. He

Jean Corot Lithograph freely drawn with crayon. *Philadelphia Museum of Art Collection.*

was a prodigy and a highly accomplished artist from the beginning, but over a long life his creative vitality never flagged. To follow his development is an education.

Developing Your Individuality

Studying the great artists individually or in groups is not for the beginning artist alone. It should be rewarding and meaningful at every stage; in fact the mature artist should have the greatest insight and appreciation of his creative forebears.

The treasury of the past is not likely to be assembled by any one person, but it is open to all to choose and profit from. The wise artist will brush aside a current philosophy which avers that individuality can flourish only if guarded against influences. Individuality is the result of influences. It cannot develop in a vacuum. To flee from influences is a sign of weakness. A talent that cannot assimilate influences without complete capitulation is a talent too meager to hope for individuality.

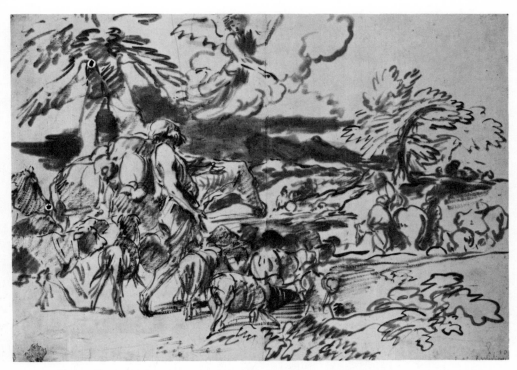

G. B. Castiglione A masterful sketch for an ambitious painting. Undoubtedly drawn from visual memory; human, animal, and vegetable forms triumphantly coordinated. *Philadelphia Museum of Art Collection.*

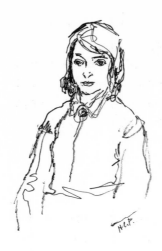

XXI. Practice and Growth

Picture-making can be either a marginal pleasure or a life-long commitment. Either way, satisfaction is linked to growth and growth is linked to practice. Growth means exercise, but exercise does not mean solely an endless chain of sketches, it also means observation, analysis, and, finally, meditation upon the fruits of observation and analysis. It is possible to grow away from the sketchbook and easel, because growth first takes place in the mind.

Thinking Visually

The committed artist cannot help thinking in pictorial terms most of the time whether he has a graphic tool in his hand or not. A large part of the time he unconsciously measures the world around him as picture material. He is mentally drawing or painting. This is both practice and growth, an exercise of his perceptive eye and imaginative, picture forming mind. It is natural and right for the artist to conceive mentally many more compositions than he will ever find time for his hand to execute.

This inquisitive interest in the visible world and the mind's active reassembling of material is the starting point of pictorial creation.

The end point of the process is the application of technique to the vision, with the purpose of executing an adequate graphic record. This whole process must be repeated again and again—the schedule for a lifetime. As practice persists, experience accumulates, more understanding arrives, the hand becomes trained. Many things become easier, but more challenging problems begin to appear on the horizon.

Away from the Drawing Board

When all is said, the artist must rely upon himself to generate this energy, interest, and will. But he has his doubts, hesitations and despairs. He needs support, understanding, and encouragement. The first place to seek these needs is in his own circle of friends and among his fellow artists. Fellow artists speak his language and understand his problems. They can criticize and exchange information. Often such groups are ready at hand, sometimes they are few and difficult to find, but the solitary artist should try to ally himself with some kindred spirits. Many communities have art leagues, museums, community centers or adult educational classes that act—or could act—as a nucleus for such a group. There are often classes to join, lecture courses to attend, or organized sketching expeditions. Some find correspondence courses helpful.

The idea is to move into the atmosphere of art, to surround yourself with sympathetic and stimulating factors. Attending regular classes in drawing, painting or design has the value of instruction as well as needful comparisons with the work of others. Although disguised, drawing or painting is competitive. Your measurements are made by comparisons, either with the work of others, or with your own ideal.

Museums and Libraries

Visiting museums and other collections is another act of stimulus and comparison. Both the old and new art have lessons to teach and the lessons are not all disclosed at first sight, particularly with the work of the greater artists. Libraries usually have some art books; some have splendid collections. Not only can you study the pictures but the biographical, historical, and critical texts are often illuminating.

If possible, you should gradually acquire your own library of art books and reproductions. Besides the art histories and books

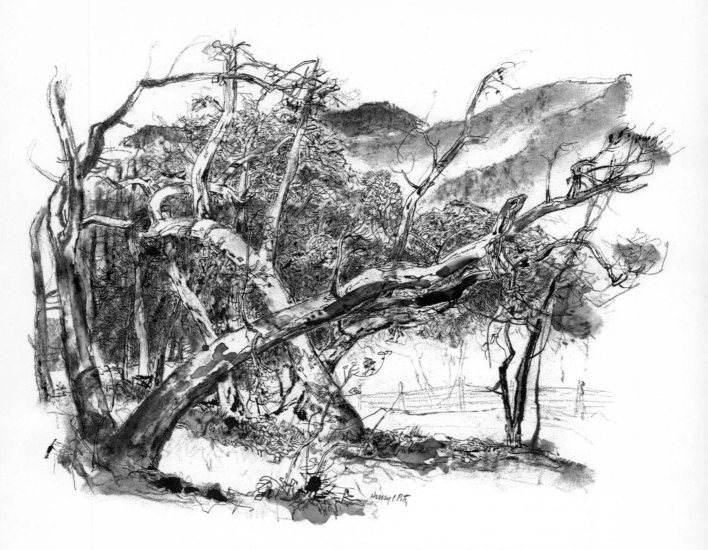

Henry C. Pitz Mixed media drawing combining pen, pencil, charcoal, and wash.

dealing with individual artists, there are a generous number of good books dealing with drawing, anatomy, design, perspective, composition, painting, and all the usual media. Fortunately, many important instructional books are now available in paperback editions at modest prices. It is often helpful to subscribe to one or more art publications, to be kept aware of current happenings in the art field: coming exhibitions, competitions, new classes.

Exhibiting Your Work

Beginning artists can seldom resist the urge to exhibit. No country has ever put on such a wholesale program of art exhibitions as

mid-century America. Inevitably, the range is from superior to mediocre and inept. There is little credit to be won in poor exhibitions. It is better to wait until your efforts are of a higher caliber, worthy to be included in exhibitions of reasonable standards. There is no question that seeing your picture upon a strange wall, surrounded by an unaccustomed array of strange pictures, induces a fresh appraisal of your own work. It teaches the lesson of the strong influence of surroundings upon a picture and the powerful effect of changing lights. And it is the easiest way of reaching an audience.

Benefiting from Discouragement

All this is part of the artist's life and although the core of his life is always the work at drawing board or easel, the peripheral activities support and feed his experience. Once committed to a serious program of picture-making, you need to work out certain strategies to sustain enthusiasm, to strengthen resolve, and to circumvent discouragement. Each artist is faced with the facts of his own temperament and must adjust his tactics accordingly.

A last suggestion may be helpful: discouragement is usually intermittent but inescapable. Discouragement loses some of its terror when you realize it is often an *encouraging* sign; it indicates dissatisfaction with and rebellion against your present level. It is a growing pain. It can be a message that you are beginning to reach out for something better. Discouragement can be an important interlude in your practice and growth.

Henry C. Pitz Line drawing in felt tip pen.

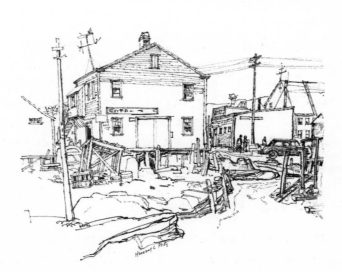

Index

Edited by Susan E. Meyer
Designed by William Harris
Composed in Times Roman by Atlantic Linotype Corp.
Printed and Bound by Interstate Book Manufacturers